Drawing Fashion

Creating a Collection

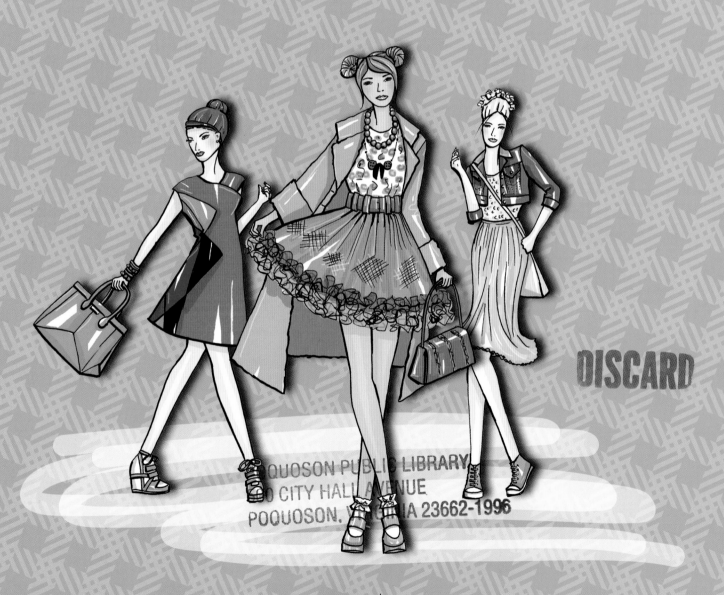

ARCTURUS

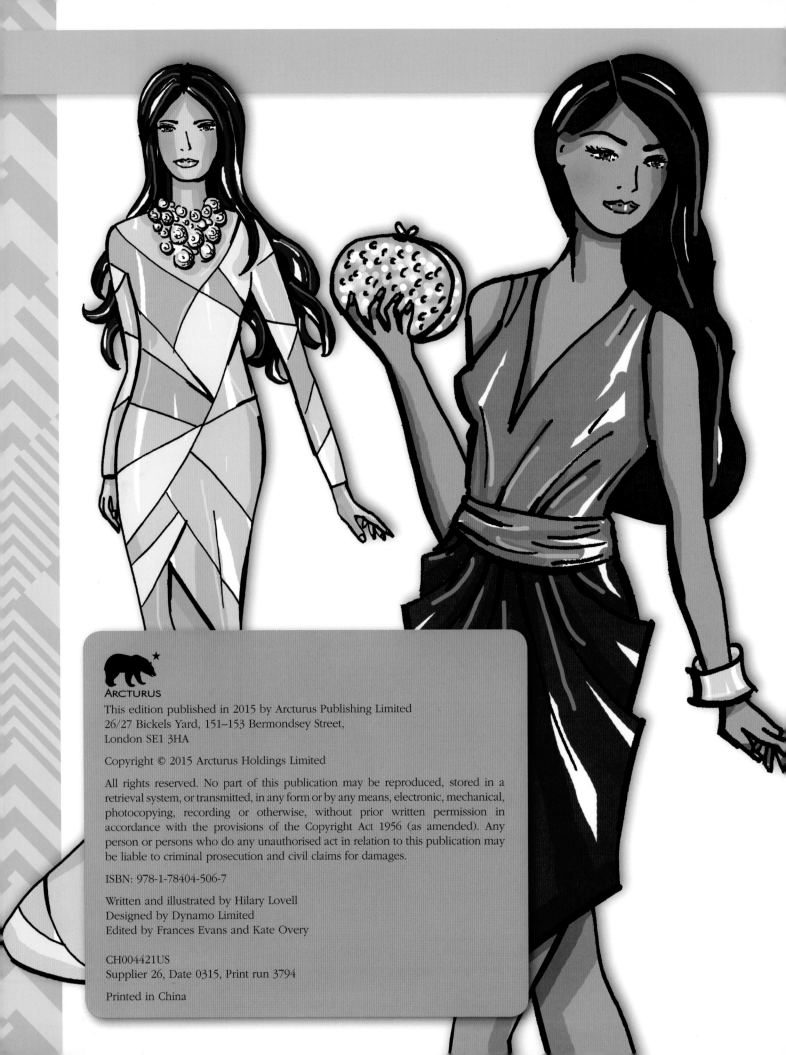

ARCTURUS

This edition published in 2015 by Arcturus Publishing Limited
26/27 Bickels Yard, 151–153 Bermondsey Street,
London SE1 3HA

Copyright © 2015 Arcturus Holdings Limited

ISBN: 978-1-78404-506-7

Written and illustrated by Hilary Lovell
Designed by Dynamo Limited
Edited by Frances Evans and Kate Overy

CH004421US
Supplier 26, Date 0315, Print run 3794

Printed in China

CONTENTS

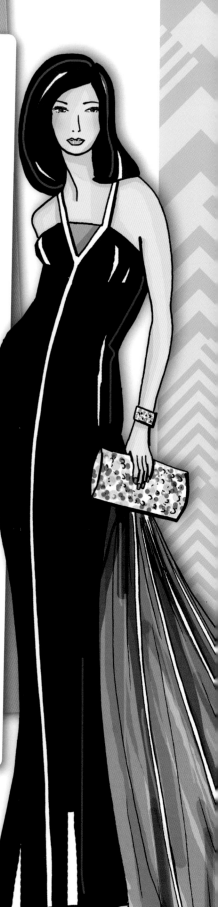

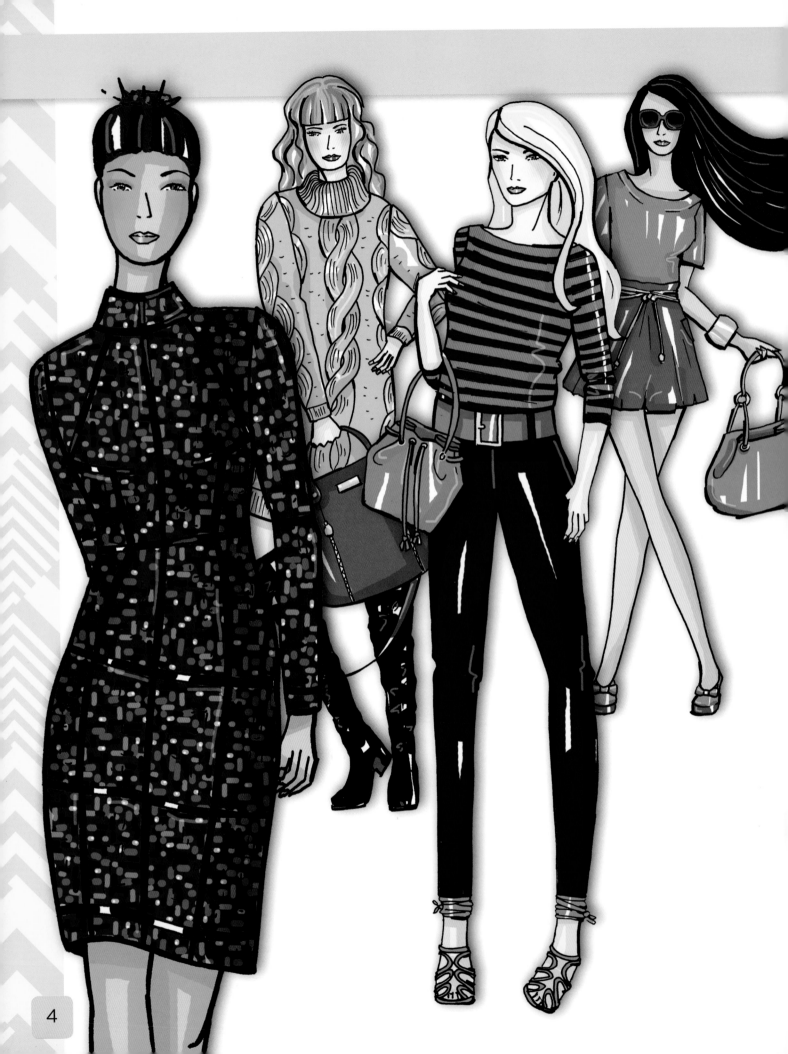

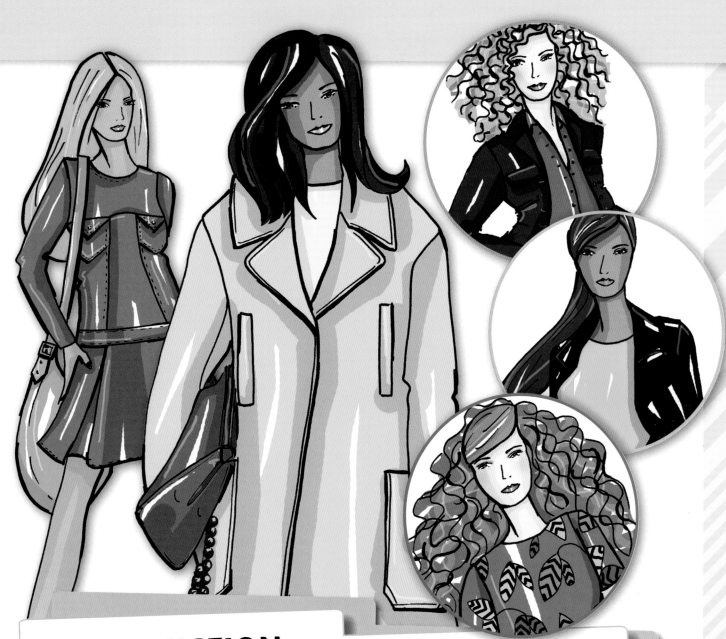

INTRODUCTION

If you have always wanted to create your own stand-out fashion collection, this book will show you how. Fashion designer Hilary Lovell reveals how top couturiers get their inspiration, put together moodboards, and combine fabrics and colors for showstopping results.

Work through the easy-to-follow steps, starting with simple pencil outlines and building up to ink and color to create fabulous finished designs. With helpful style cards at the end of every section, you can complete each look with the perfect accessories for a collection that is all your own!

DRAWING TECHNIQUES AND TOOLS

Let's start by looking at the techniques and tools you'll need to create your fashion model. Before you begin, experiment with mark-making using your pencil. Warm up your hand by practicing some of these easy techniques. Try using a mix of sharp and blunt pencils to create different effects.

Cross-hatching:
Use for check prints on fabric.
Wavy lines:
Great for creating a curly hairstyle.
Stippling:
Use to get a sequin or bead effect.
Pebble texture:
Ideal for creating button details.
Scribble stroke:
For a messy updo.
Parallel line stroke:
Good for stripes on garments.

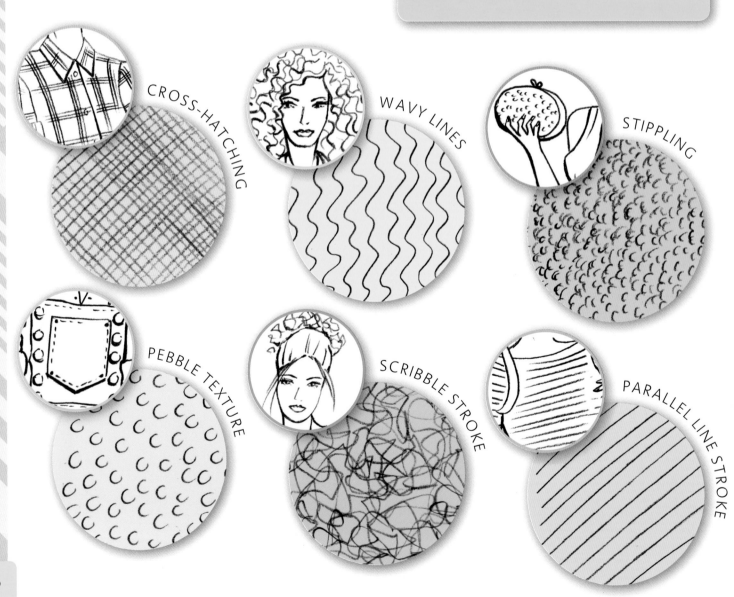

CROSS-HATCHING

WAVY LINES

STIPPLING

PEBBLE TEXTURE

SCRIBBLE STROKE

PARALLEL LINE STROKE

DRAWING TOOLS

You can have a lot of fun experimenting with different pencils, paints, and inks. It's a good idea to invest in the essentials, then build up your collection of drawing tools over time.

PAPER

There are so many different types of paper that it can be difficult to know which is best for your drawings. Start with a basic, inexpensive paper, such as layout paper, while you experiment with the different features of your characters. When you have a rough drawing you are happy with, move onto a heavier, higher-quality paper for your final version, such as watercolor or cartridge paper.

PENCILS

Most of your work will be done in pencil, so it's a good idea to make sure you are comfortable with the type of pencil you choose. Graphite, or lead, pencils come in different grades and are marked "B" for blackness, or "H" for hardness. "2H" is a good pencil to start with, as it leaves clean lines and few smudges. From here you can experiment with other pencils until you find one you like. A technical pencil is useful for drawing thinner lines, and the lead breaks less often than with a traditional pencil.

PENS

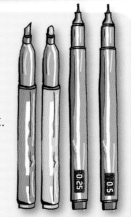

The most important thing to consider when choosing a pen is how you plan to color your art. If you want to color your model with water-based paints, you will need a waterproof ink pen. The nib thickness is usually marked on the lid, and ranges from 0.1 (thinnest) to 0.5 (thickest). Nib thicknesses 0.2 and 0.3 are good for most lines, with 0.1 best for inking fine details.

PAINTS & BRUSHES

Most art stores stock a variety of paints including: acrylics, watercolors, oils, and gouache. If you want to color your characters by hand, it is best to experiment with different paints until you find one you are comfortable with. Another way to ink your work is with a fine brush. This technique requires a very steady hand, and a good-quality sable brush. Brushes are great for adding glitter or sparkle details.

CREATING YOUR COLOR PALETTE

One of the most important skills needed in fashion design is a good understanding of colors and how they work together. A color wheel is a great way to get to grips with the basics.

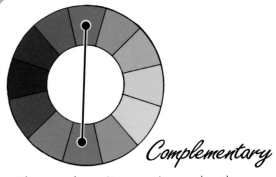

Complementary

These colors sit opposite each other on the color wheel. When used together, they create a great contrast. For example, red and green.

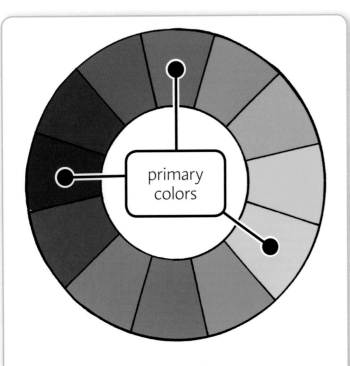

primary colors

The Color Wheel

To start with, there are three primary colors—red, blue, and yellow.

The primary colors cannot be made by mixing colors together.

All other colors are created by mixing colors together.

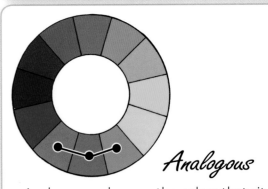

Analogous

Analogous colors are the colors that sit next to each other on the color wheel. They match one another well. For example, light blue, green, and light green.

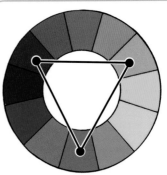

Triadic

Triadic colors are evenly spaced around the wheel. Used together these create a bright, vibrant color palette. For example, green, purple, and orange.

Create a color palette using triadic colors.

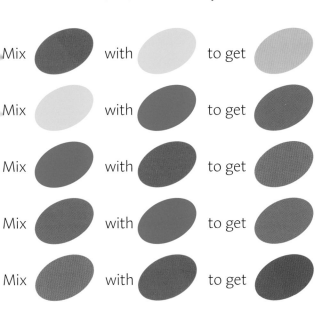

Mix ⬭ with ⬭ to get ⬭

Mix ⬭ with ⬭ to get ⬭

Mix ⬭ with ⬭ to get ⬭

Mix ⬭ with ⬭ to get ⬭

Mix ⬭ with ⬭ to get ⬭

Add white to your color to create a pastel color palette.

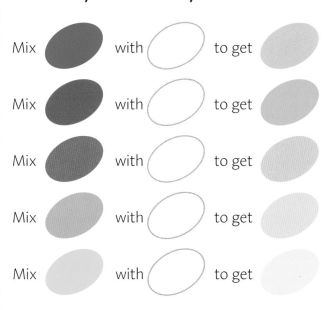

Mix ⬭ with ⬭ to get ⬭

Mix ⬭ with ⬭ to get ⬭

Mix ⬭ with ⬭ to get ⬭

Mix ⬭ with ⬭ to get ⬭

Mix ⬭ with ⬭ to get ⬭

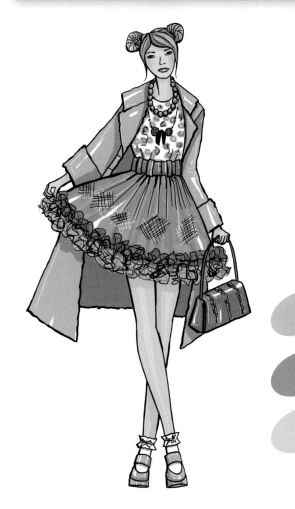

GETTING YOUR INSPIRATION

Cutting-edge couture is all about bringing together statement styles to create fresh and exciting looks. The best catwalk designers make outfits that feel modern and unique but can also inspire everyday fashions. Here are some ideas to inspire your own designs.

CUTTING EDGE

- Keep an eye on the latest catwalk collections at big shows like Paris, London, or Milan.
- Visit local fashion shows. You could even organize a fashion show of your own with friends.
- Follow fashion blogs and online magazines to see what's on trend.
- Familiarize yourself with designers and iconic styles that appeal to you.

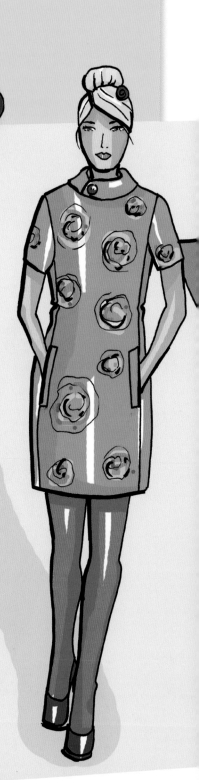

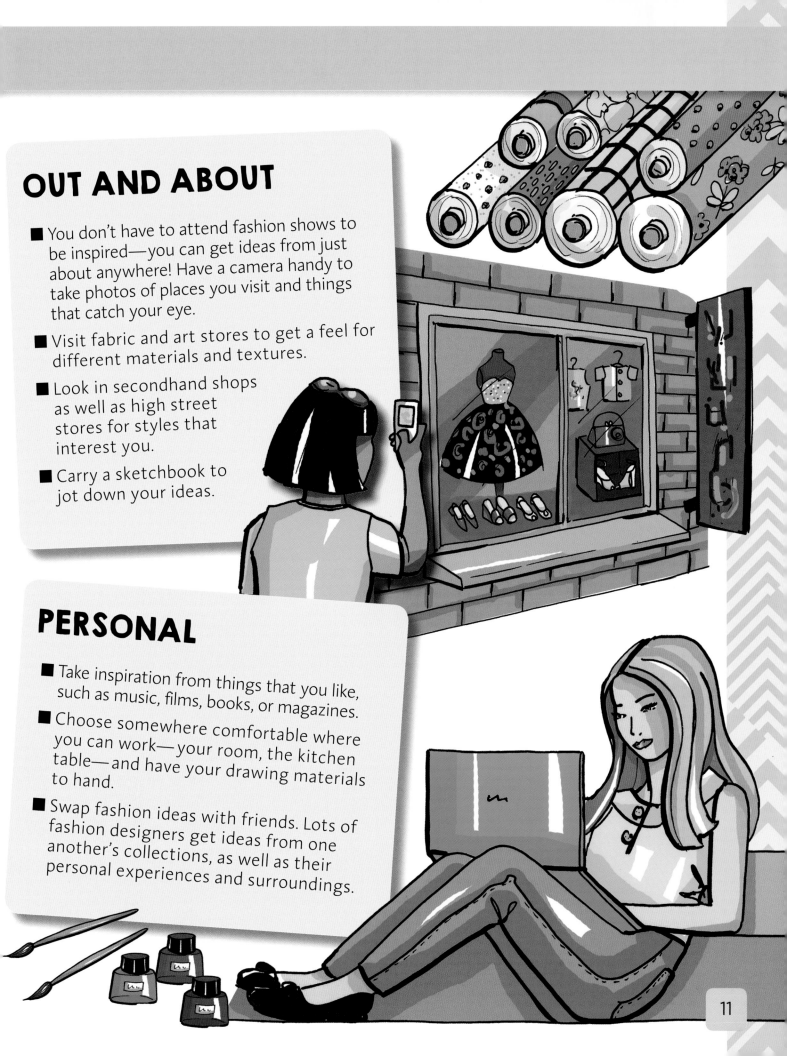

OUT AND ABOUT

■ You don't have to attend fashion shows to be inspired—you can get ideas from just about anywhere! Have a camera handy to take photos of places you visit and things that catch your eye.

■ Visit fabric and art stores to get a feel for different materials and textures.

■ Look in secondhand shops as well as high street stores for styles that interest you.

■ Carry a sketchbook to jot down your ideas.

PERSONAL

■ Take inspiration from things that you like, such as music, films, books, or magazines.

■ Choose somewhere comfortable where you can work—your room, the kitchen table—and have your drawing materials to hand.

■ Swap fashion ideas with friends. Lots of fashion designers get ideas from one another's collections, as well as their personal experiences and surroundings.

FASHION MOODBOARDS

Moodboards play a very important role in the world of fashion. This is where a fashion designer pulls together materials they have sourced to create the starting point or theme for their collection.

Try putting together your own moodboard. A great way to start is by collecting images, swatches of fabric, and embellishments that you really love and that work well together. When you have a selection you like, place them carefully on a piece of board. Move them around until you are happy with how they look, then stick them in place.

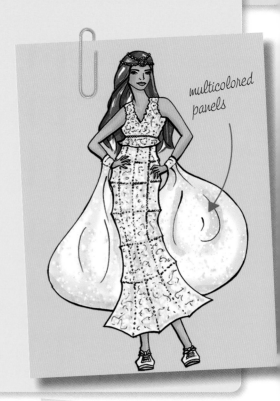

multicolored panels

THINGS FOR YOUR MOODBOARD

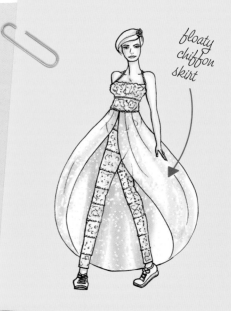

floaty chiffon skirt

- Collect images of fashion items you like from magazines, the internet, your own photos, or sketches.
- Add small fabric swatches.
- Cut embellishments from old clothes you don't want anymore and use them for inspiration.
- Create your own color palette with colors from your moodboard, using the color wheel to decide what works well together.

Now it's time to get creative! Take inspiration from your moodboard to create your own unique fashions. If you have too many ideas for just one outfit, why not design an entire collection!

Here we have been inspired to create a moodboard of beautiful beaded accessories using pictures and swatches that we have found.

Sequined bag

Pastel beads

Bold textures

Bejeweled slip-ons

COLOR-BLOCKING COLLECTION

Stand out from the crowd and go big, bold, and beautiful with this cool, color-blocking technique. Mix and match vibrant accessories and clashing colors that seem so wrong they can only be right—then wear them with attitude!

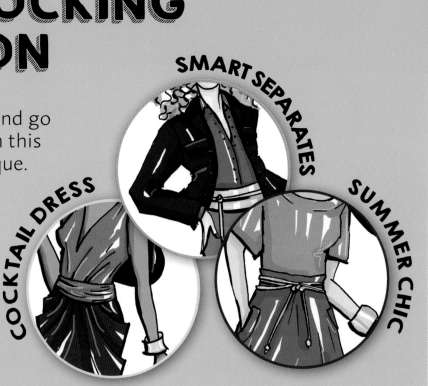

COCKTAIL DRESS

SMART SEPARATES

SUMMER CHIC

COCKTAIL DRESS

This sophisticated dress is perfect for a cocktail party or a night out. Accessorize with a sparkly sequined clutch bag and matching shoes. Add ankle socks for a dressed-down, girly feel.

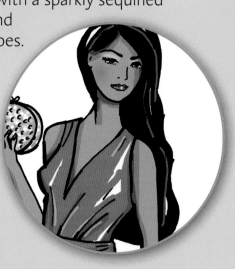

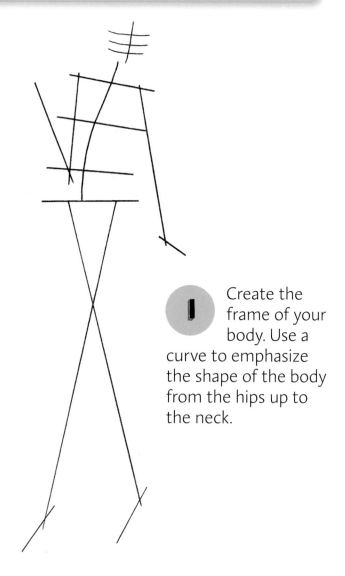

1 Create the frame of your body. Use a curve to emphasize the shape of the body from the hips up to the neck.

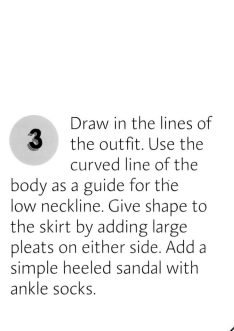

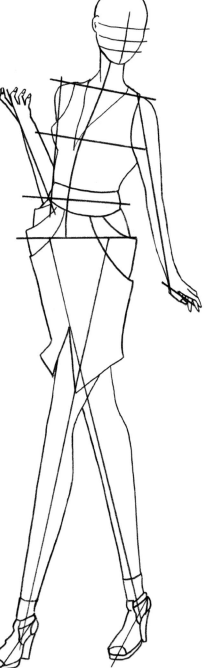

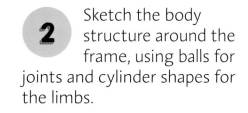

2 Sketch the body structure around the frame, using balls for joints and cylinder shapes for the limbs.

3 Draw in the lines of the outfit. Use the curved line of the body as a guide for the low neckline. Give shape to the skirt by adding large pleats on either side. Add a simple heeled sandal with ankle socks.

Color-Blocking Collection

4 Add the features of the face and work up the hairstyle. A soft, long wavy style in a side parting works well with this elegant outfit.

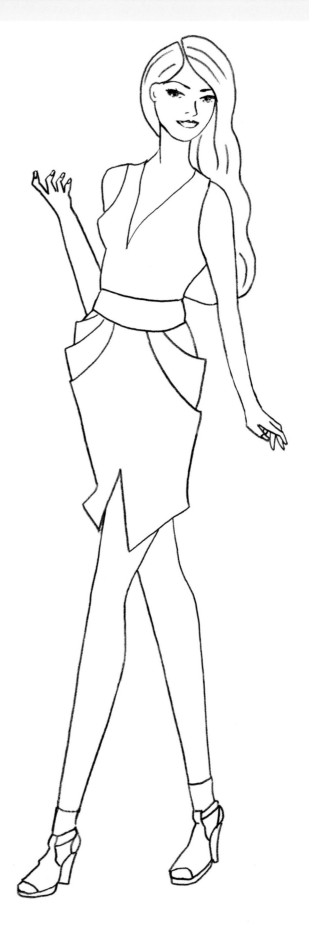

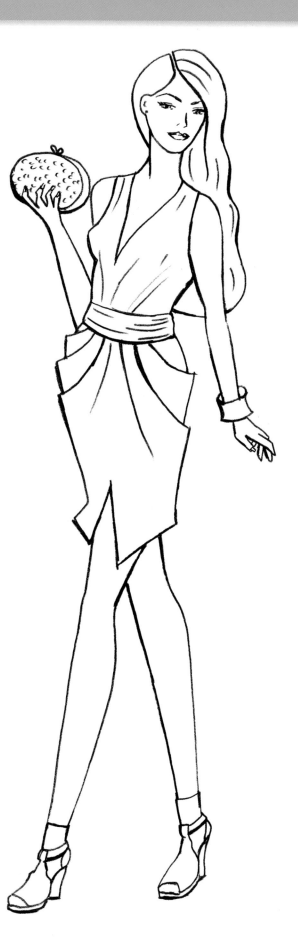

5 Add some pleat lines to the skirt, top, and belt to give more texture to the fabric.

Add an accessory

Here we have used a stippling effect for the heavily sequined clutch bag. Finish the look with a simple, chunky bracelet.

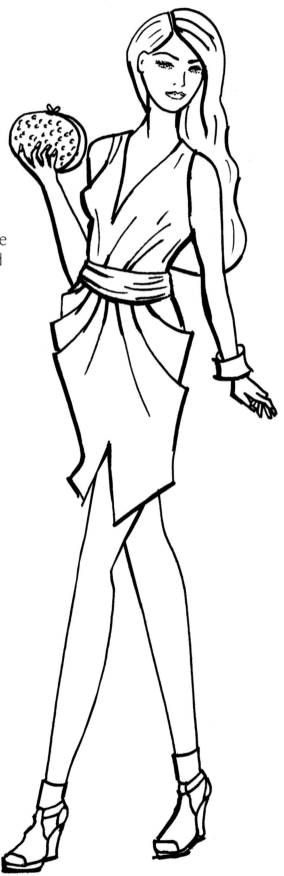

6 Start to ink your pencil. Use thicker lines for the outline of the dress and shoes, and thinner lines for the pleats and through the hair for texture.

7 Use a vibrant color for the top and a darker shade for the skirt to give the outfit balance. A bright pink sash belt completes the color-blocking effect. Give the outfit more sparkle by using silver for the sequined clutch bag, bracelet, and shoes.

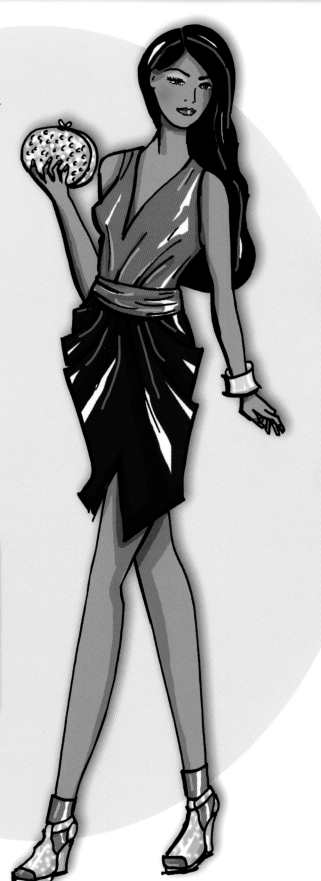

Stylist's Tip

Leave some white highlights to show where the shiny fabric catches the light.

SMART SEPARATES

Complement this beautifully tailored jacket and pants with glamorous, gold accessories, ideal for day or night.

1 Start by drawing straight lines to create the frame. Give the model a strong pose with shoulders back and hips pushed forward.

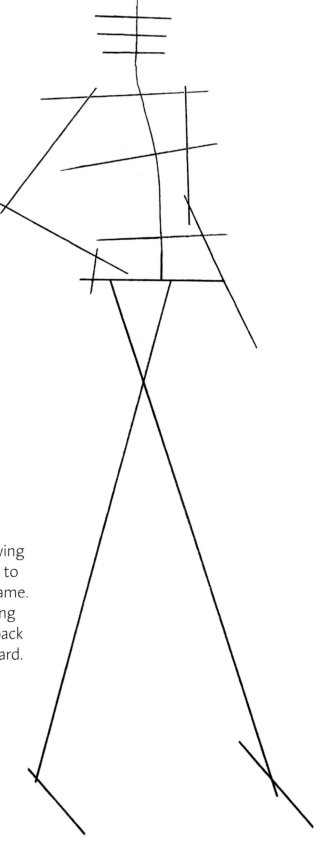

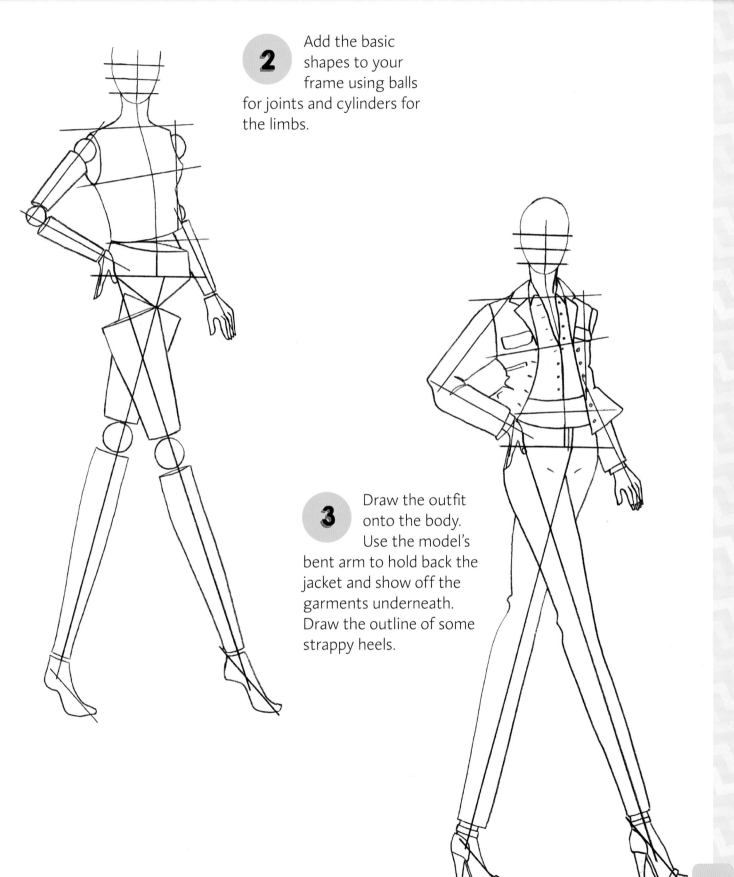

2 Add the basic shapes to your frame using balls for joints and cylinders for the limbs.

3 Draw the outfit onto the body. Use the model's bent arm to hold back the jacket and show off the garments underneath. Draw the outline of some strappy heels.

Color-Blocking Collection

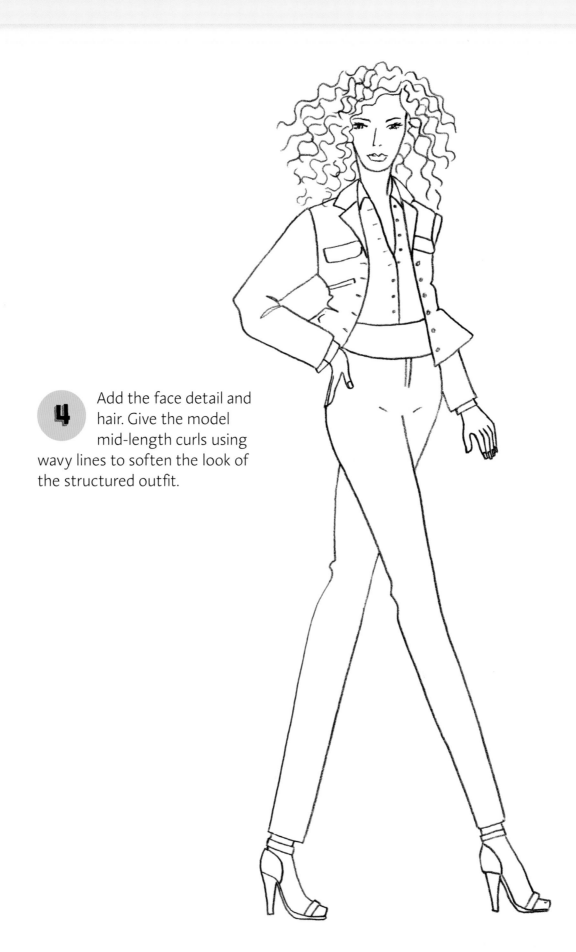

4 Add the face detail and hair. Give the model mid-length curls using wavy lines to soften the look of the structured outfit.

5 Now add some simple accessories. A clutch bag and string belt are all that are needed to bring a touch of class to this casual outfit.

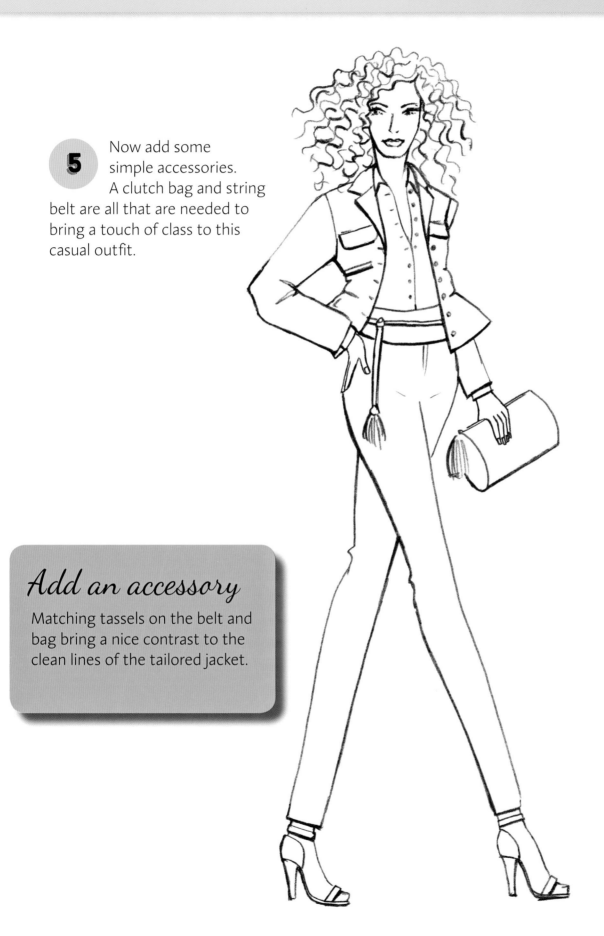

Add an accessory

Matching tassels on the belt and bag bring a nice contrast to the clean lines of the tailored jacket.

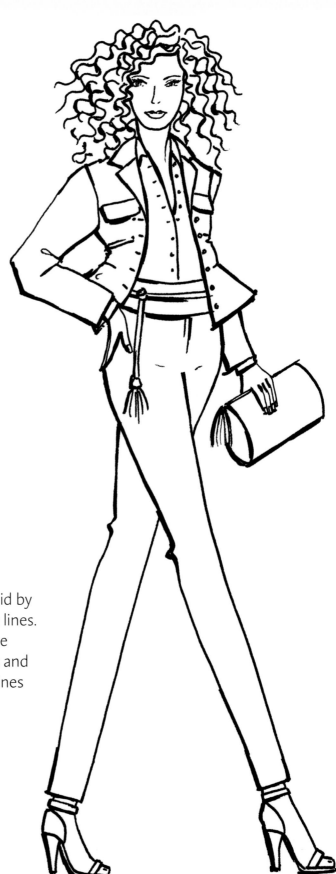

6 Ink your drawing, keeping the look fluid by using thick and thin lines. Use a thin pen to draw on the fine details, like button holes and buttons. Use thick and thin lines in the hair to give it texture.

7 Choose three strong colors for your outfit. Pick out one or two of these block colors in the shoes and tassels to help pull the outfit together. Gold accessories enhance the sense of glamour.

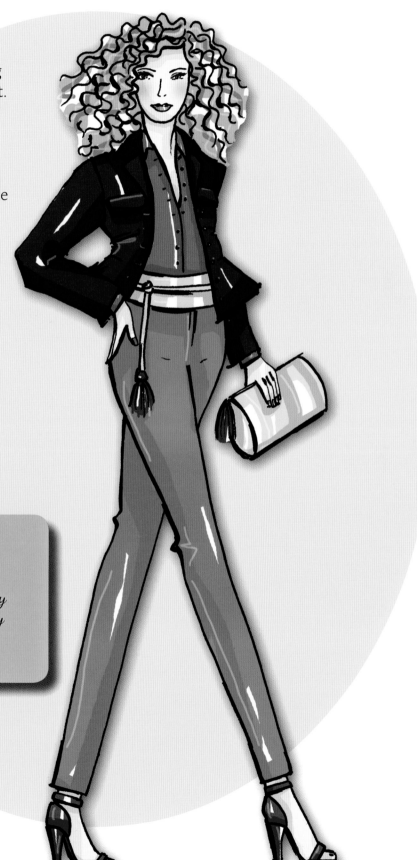

Stylist's Tip

Give the gold accessories plenty of highlights to show how they catch the light.

SUMMER CHIC

Make your summer sizzle with these bright shorts and contrasting T-shirt. Add a shot of chic with a simple chunky bracelet—and don't forget the shades!

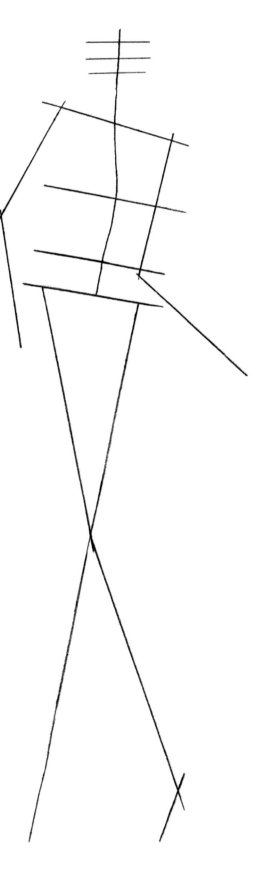

1 Begin by drawing your model frame. Keep the pose casual by tilting the shoulders and crossing the legs.

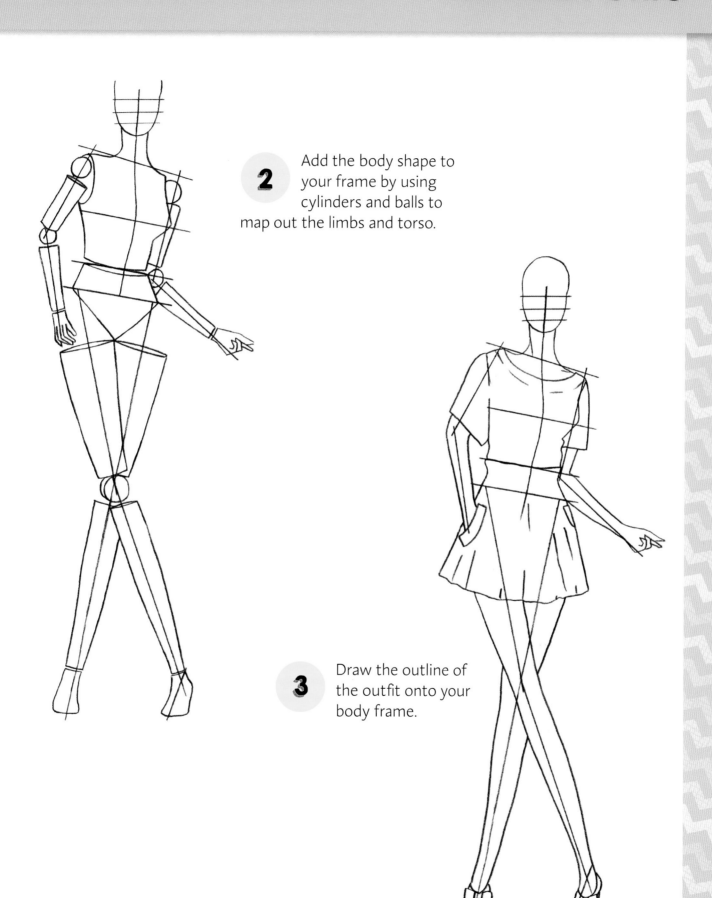

2 Add the body shape to your frame by using cylinders and balls to map out the limbs and torso.

3 Draw the outline of the outfit onto your body frame.

Color-Blocking Collection

4 Remove the frame and draw on the model's face and hair. Use thick and thin sweeping lines that flick out to the side to create movement in the pose.

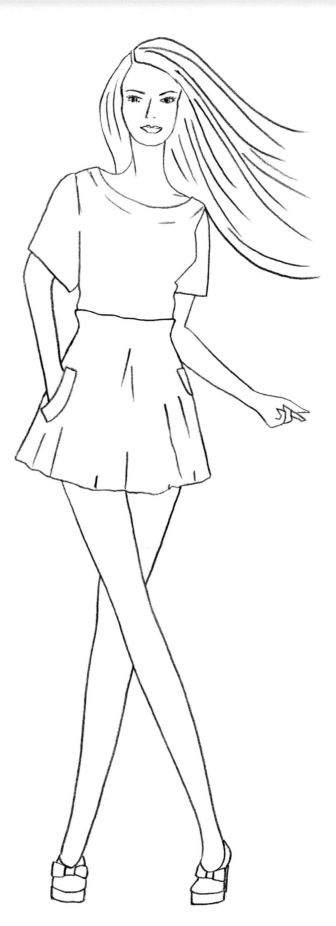

5 Now to accessorize your model! Make a statement with some big shades, a slouchy shoulder bag, and a chunky bangle. A wraparound string belt finishes the look.

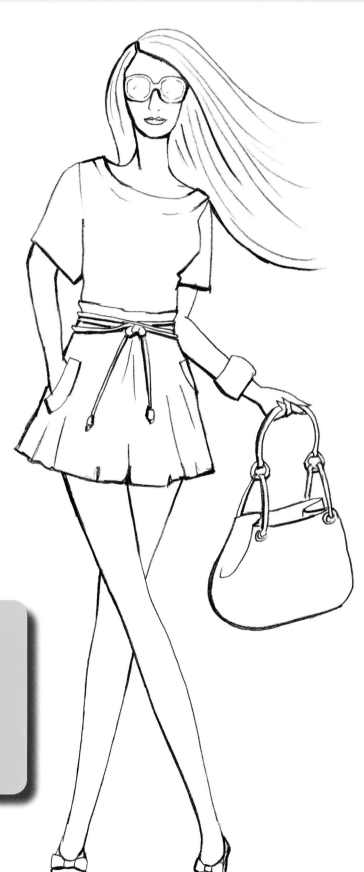

Add an accessory

Oversized accessories work well with this understated outfit. The belt echoes the string-style handle of the handbag.

Color-Blocking Collection

6 Ink around your model using thicker lines at the base of the shorts, and also under the shoes and bag to show where there will be shadow.

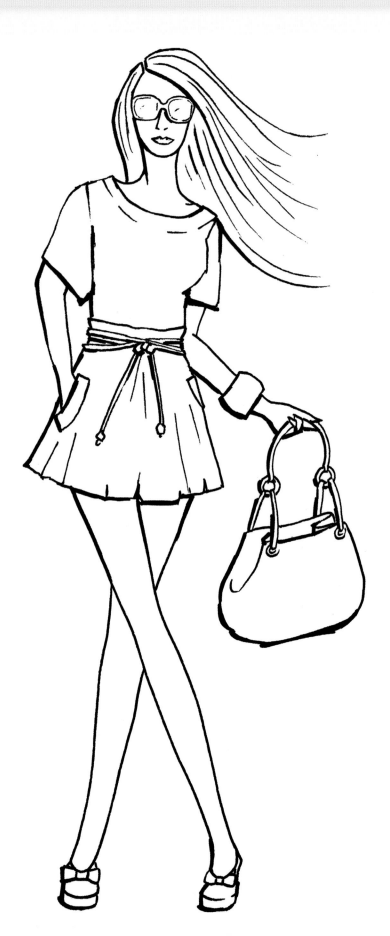

7 Color up your model using bright, contrasting colors. Pink and orange work well together as block colors. Enhance these with turquoise and gold accessories. Tie the colors together by using pink on the sunglasses and soles of the shoes.

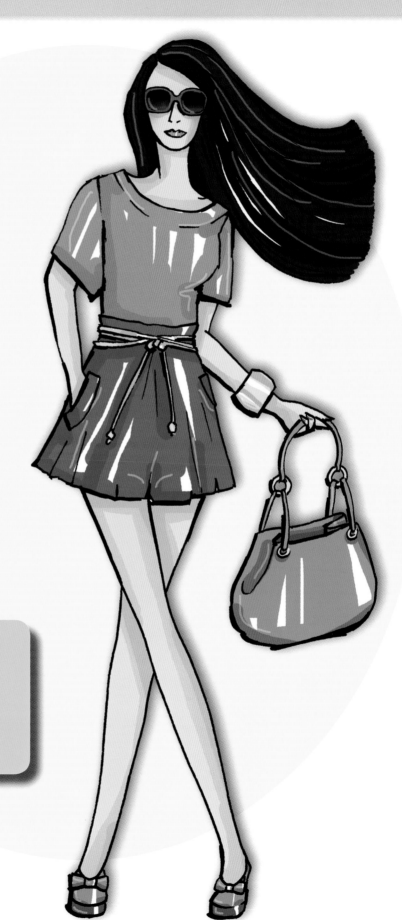

Stylist's Tip

Use different shades of brown in the hair and leave some highlights for a glossy look.

STYLE CARDS

Color-blocking is perfect for a zingy, bold look. You can enhance a full block-color style with some great accessories, or just add a piece or two to brighten up any outfit. This look is funky and fun.

Dip-dye the ends of long hair.

Block color the front of sweeping bangs.

Accessories

Add some flashes of fabulous color with a few carefully chosen accessories.

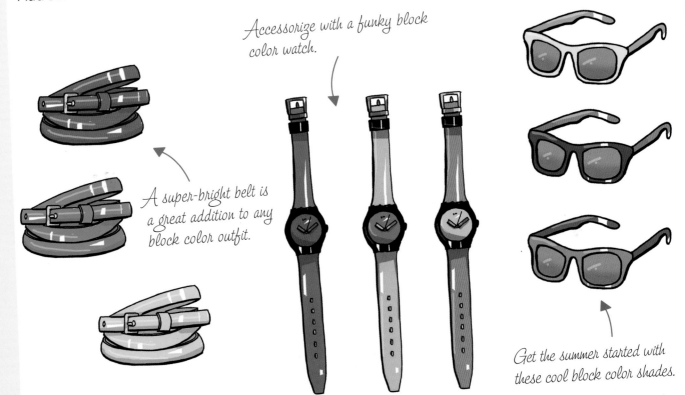

Accessorize with a funky block color watch.

A super-bright belt is a great addition to any block color outfit.

Get the summer started with these cool block color shades.

Bags

A vibrantly colored bag can be used to pull together the colors on your block color outfit, or it can look fabulous as a stand-alone item.

A block color envelope clutch is a great way to give a sophisticated look to an evening outfit.

Team this bag with a simple black outfit to make it really stand out.

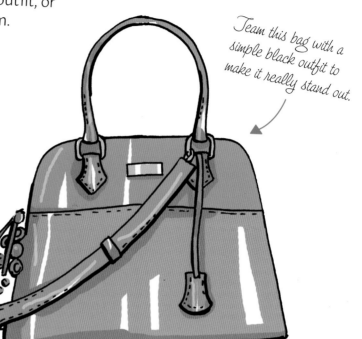

Up the wow-factor with these multicolored tipped nails.

Shoes

Get the look from head to toe with these fabulous block color shoes.

Keep it subtle in these block color sandals.

Make a statement in these peep-toe platform heels.

DENIM COLLECTION

Denim is not just about jeans. Give a twist to a modern classic by pairing it with fun accessories and eye-catching stitch details. Follow the steps on these pages to bring some dazzling style to everyday denim!

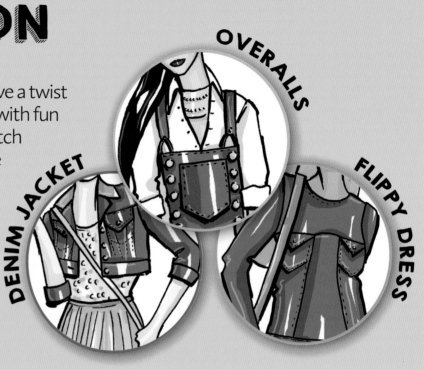

OVERALLS

DENIM JACKET

FLIPPY DRESS

DENIM JACKET

Show that denim doesn't have to be dull by placing this gorgeous mini-jacket over a sequined top and flowing, pleated skirt.

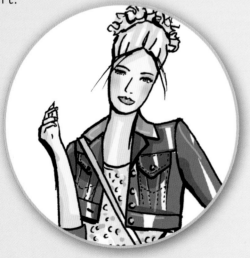

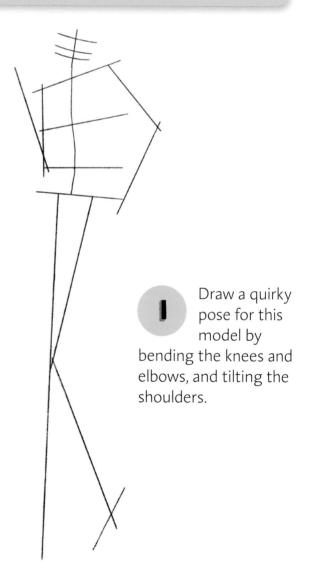

1 Draw a quirky pose for this model by bending the knees and elbows, and tilting the shoulders.

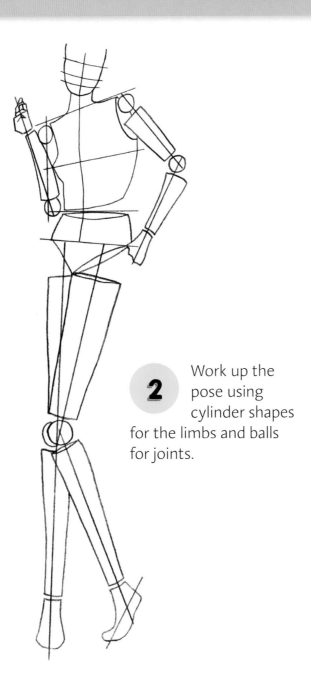

2 Work up the pose using cylinder shapes for the limbs and balls for joints.

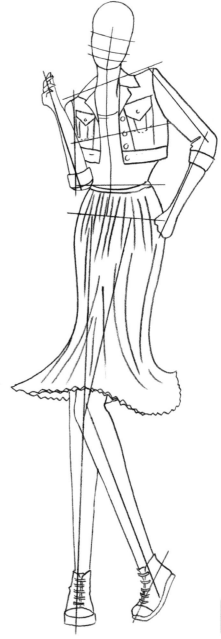

3 Add the outfit detail to your frame. Draw the jacket, keeping it open at the front to show the top underneath. Give the skirt lots of movement by using sweeping lines for the pleats and kicking it out at the hem. Draw the outline of some simple high-top sneakers.

4 Add the facial features and use scribble strokes to create a pulled back updo hairstyle. Have loose hair coming down at the sides to soften the look. Draw the denim stitching detail on the jacket with a sharp pencil.

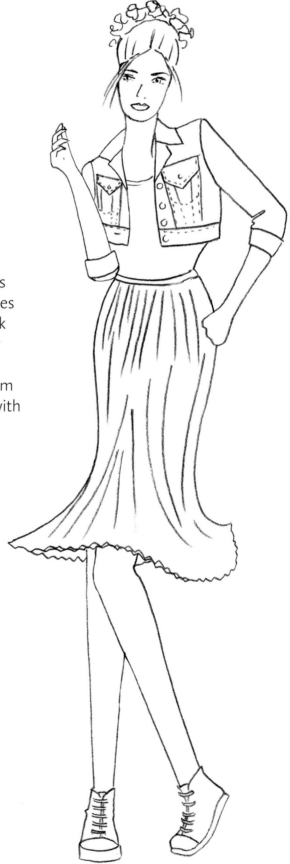

5 Add sequin detail to the top and a casual shoulder bag, using the hand to hold the strap.

Add an accessory

Having the strap of this simple holdall sitting across the body helps to make a statement all of its own.

6 Ink up your pencil drawing using thick and thin lines for the skirt hemline to show the pleats. Use thicker lines around the jacket seams, collar, and cuffs.

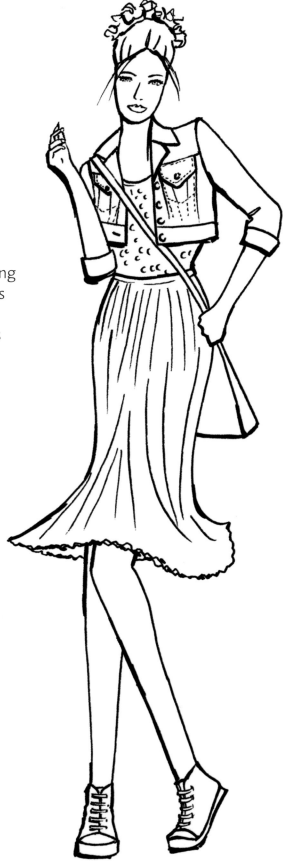

7 Use soft, pastel colors for the skirt, bag, and top to contrast with the dark blue denim jacket. Add a turquoise collar and color the sneakers to match it.

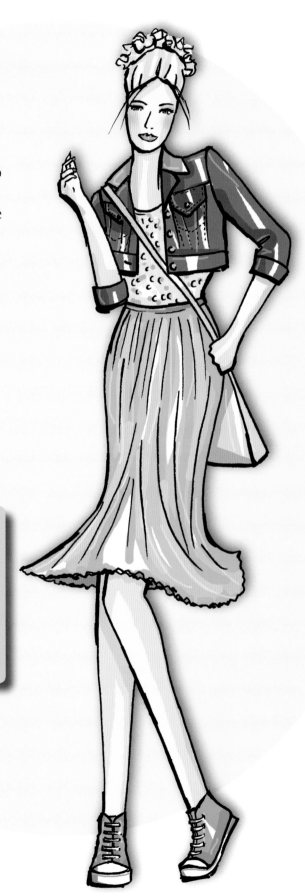

Stylist's Tip

Use different shades of pink on the skirt to show the pleated effect of the fabric.

OVERALLS

Give your overalls some street-style glamour by teaming up your denim with gold accessories and oversized pocket details.

1 Use lines to create your body frame. Position the arms so that the hands will sit in the pockets. Tilt the shoulders and widen the legs for a casual pose with attitude.

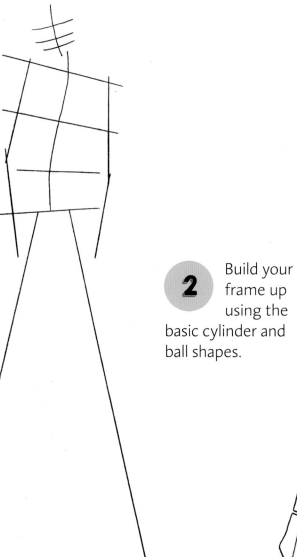

2 Build your frame up using the basic cylinder and ball shapes.

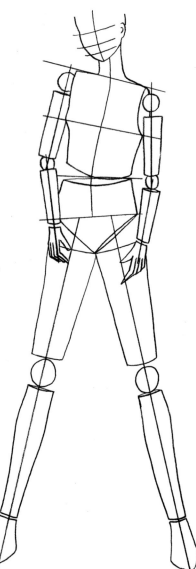

3 Add the detail of the outfit to your frame. Draw a casual shirt with rolled cuffs. Give the overalls an oversized pocket on the top panel and button detail down either side. Add pockets at the hips for the hands. Give this tomboy look a girly edge with some pointy shoes.

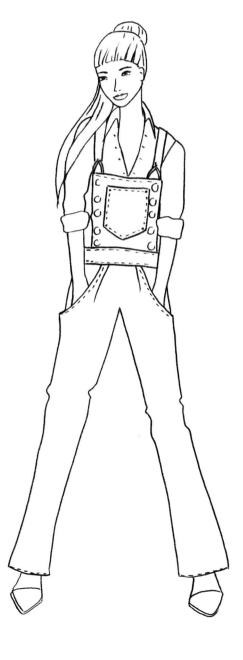

4 Remove the frame lines and draw on the facial features. Give the model a long, high ponytail falling over one shoulder. Finish off by adding stitching detail around the pockets and waist.

Denim Collection

5 Time to add the accessories! A chunky collar necklace and matching cuff bracelet work well with the exposed neck and wrist. Use a stippling effect to give them texture.

Add an accessory

We have brought a touch of bling to this classically casual outfit. The statement jewelry is a total contrast to the laid-back overalls.

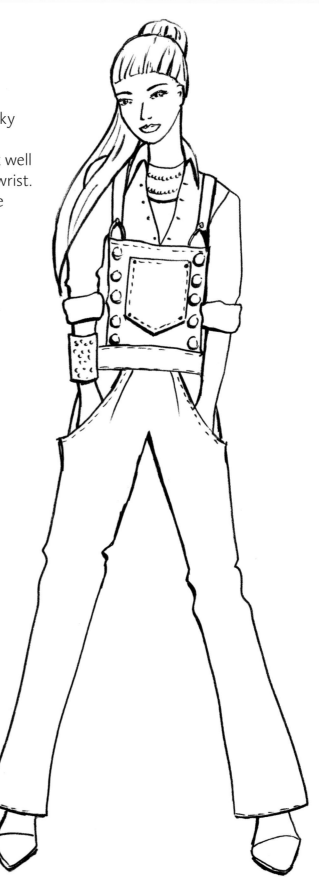

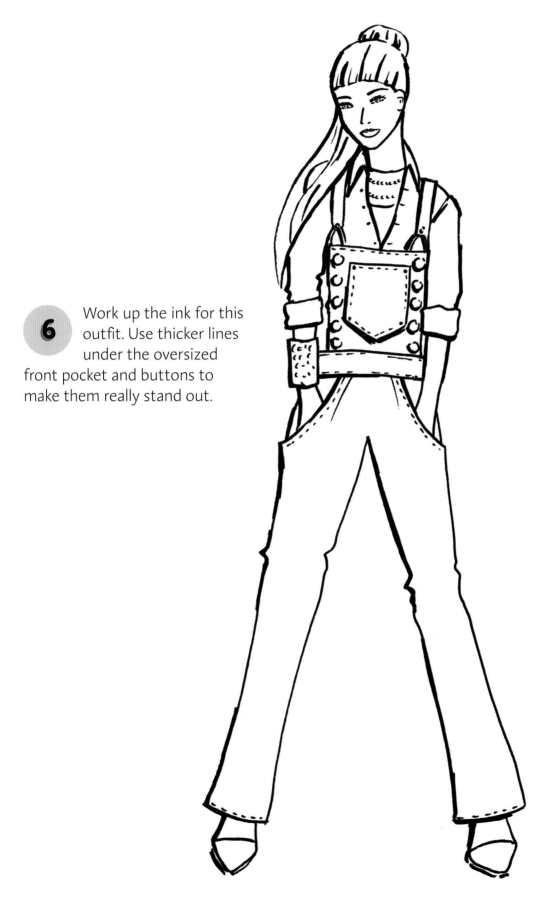

6 Work up the ink for this outfit. Use thicker lines under the oversized front pocket and buttons to make them really stand out.

7 Add glamour to this outfit by using gold for the jewelry, shoes, and buttons. These will sit well with a crisp white shirt.

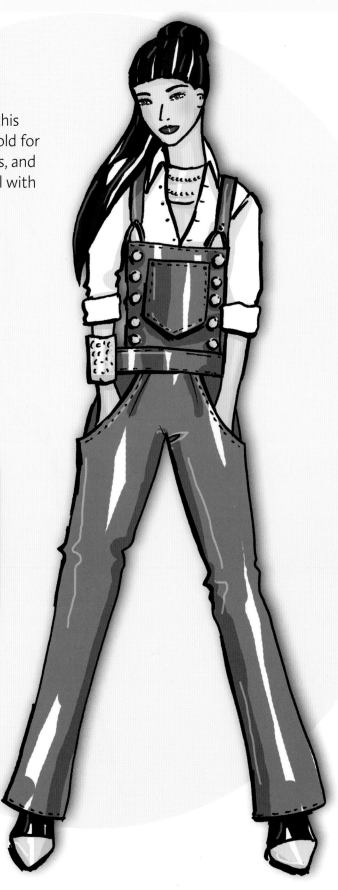

Stylist's Tip

Leave some highlights in the hair to give it a sleek look.

FLIPPY DRESS

Give your denim character with this cool drop-waisted dress. Use classic denim jacket pockets and seam detail but add cowboy boots and a large shoulder bag for an extra twist.

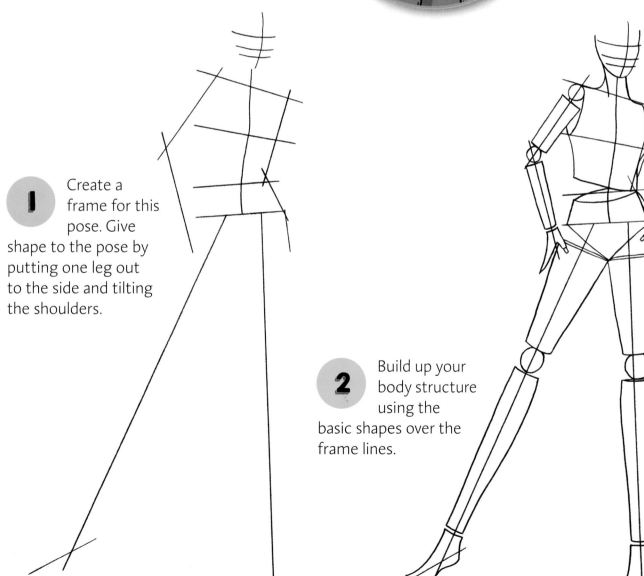

1 Create a frame for this pose. Give shape to the pose by putting one leg out to the side and tilting the shoulders.

2 Build up your body structure using the basic shapes over the frame lines.

Denim Collection

3 Add the lines of your dress onto the body. Follow the basic model frame for the seams on the top panel and skirt pleats. Draw the pleats, making them soft and fluid to give them movement. Add statement ankle cowboy boots.

4 Remove the frame lines and, using a sharp pencil, draw stitching detail along the seams of the dress and boots. Keep the hair simple with a long, flowing style in a center parting.

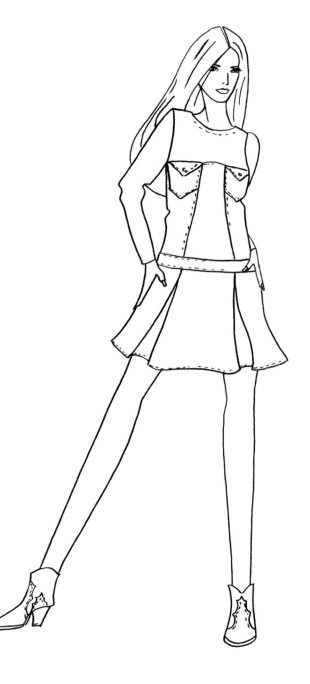

5 Add a large shoulder bag with buckle detail to this outfit.

Add an accessory

Draw the oversized bag hanging behind the leg so that it enhances the overall look but does not distract from the dress.

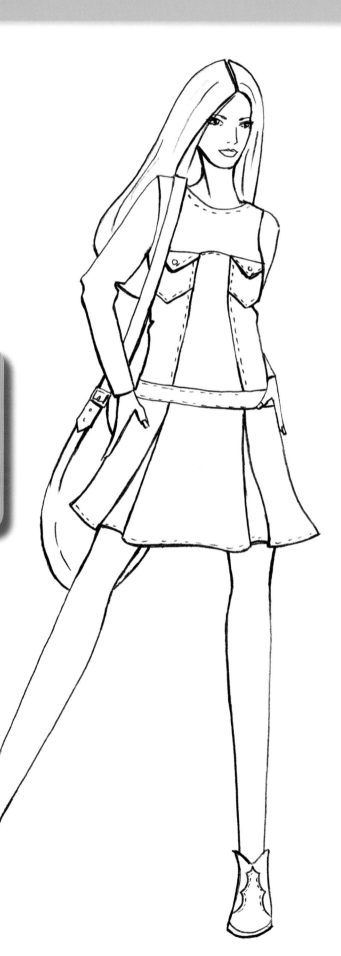

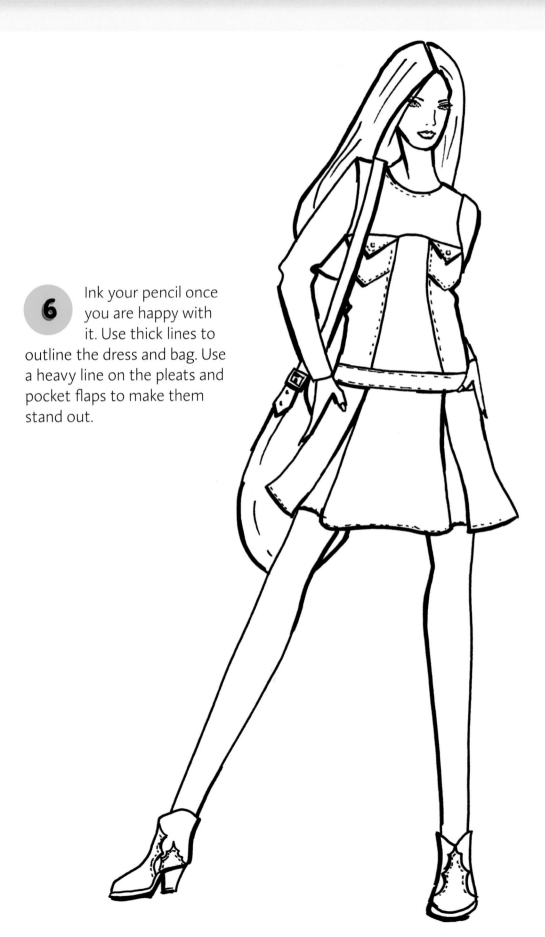

6 Ink your pencil once you are happy with it. Use thick lines to outline the dress and bag. Use a heavy line on the pleats and pocket flaps to make them stand out.

7 Add color to the denim outfit by using tan for the boots and a soft green for the bag.

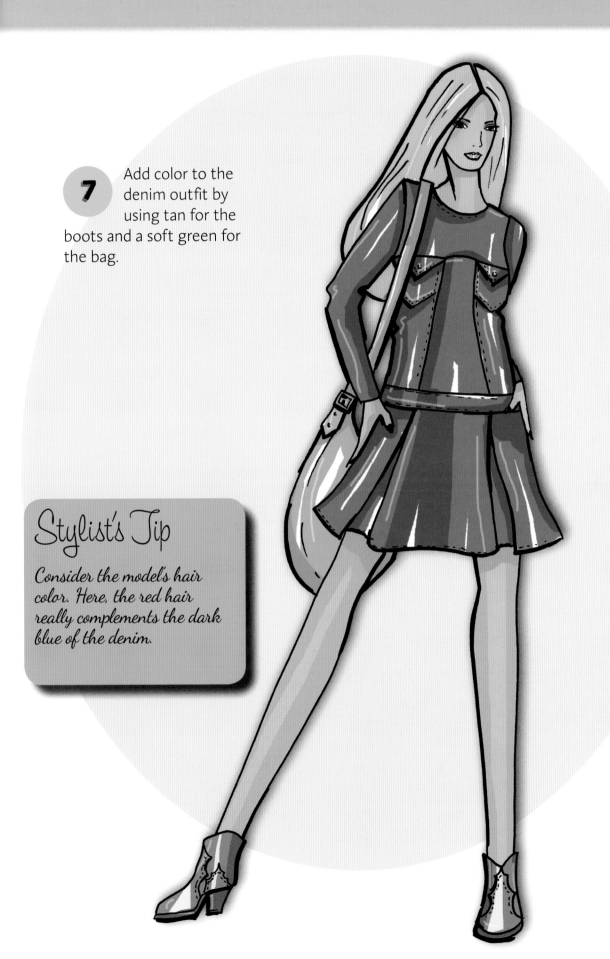

Stylist's Tip

Consider the model's hair color. Here, the red hair really complements the dark blue of the denim.

Denim Collection

STYLE CARDS

Denim looks great whatever the style, be it dyed, shrunk, bleached, or faded. And don't just save it for your jeans and jackets—this versatile fabric can work for anything, from a glamorous clutch, to a cute pair of low-cut shoes!

Accessories

Denim can literally be used to accessorize from head to toe! Go for a statement hat and scarf, or keep it subtle with delicate denim touches.

This tie-dyed sun hat is a perfect addition to any summer wardrobe.

Go wild with this denim-mix floral hairband.

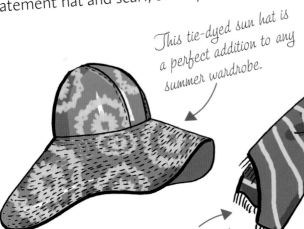

Get super-stripy with this fun denim scarf.

Keep your do in place with denim rose hair clips.

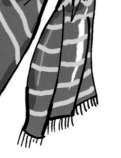

Gathered denim earrings give you dangles without the jangles!

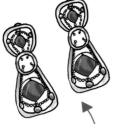

Add some glamour with these denim drop earrings.

Get the look with denim-effect nail decals.

Bags

Denim bags, large or small, can make a real statement. Keep the look plain and simple or enhance it with studs, beads, sequins, or a splash of color.

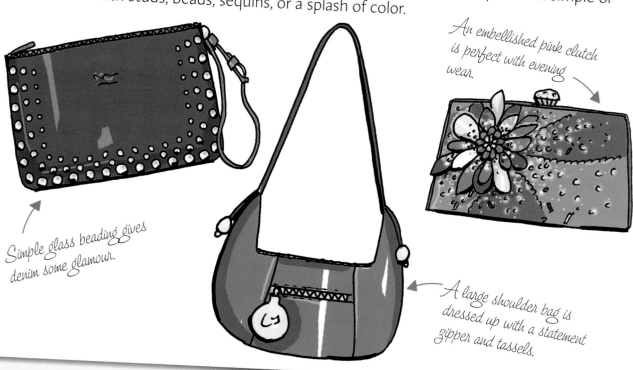

An embellished pink clutch is perfect with evening wear.

Simple glass beading gives denim some glamour.

A large shoulder bag is dressed up with a statement zipper and tassels.

Shoes

Fun fabric footwear is a great way of mixing denim with the rest of your outfit, whether it's killer heels, low-cut shoes, or sports shoes.

These dainty low-cuts are the perfect way to wear denim every day.

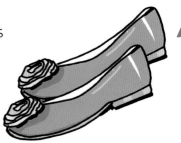

Get the sporty look with these multi-denim fabric sneakers.

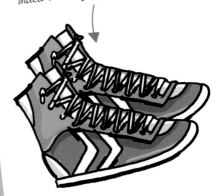

Rock these killer heels with a cool zipper detail.

GEOMETRIC COLLECTION

Get inspired by exciting shapes from your geometry class. Think grids, triangles, and concentric circles. Anything goes—and it goes on anything!

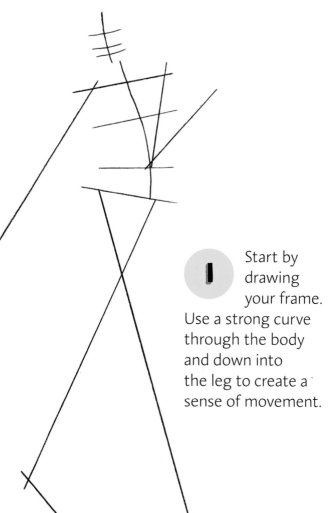

GEO PANTS

SPORTY DRESS

MAXI DRESS

SPORTY DRESS

Shape up with this simple but stylish geometric print dress. Team the contrasting colors with chunky jewelry and sporty accessories, and it all adds up to make one knockout outfit!

1 Start by drawing your frame. Use a strong curve through the body and down into the leg to create a sense of movement.

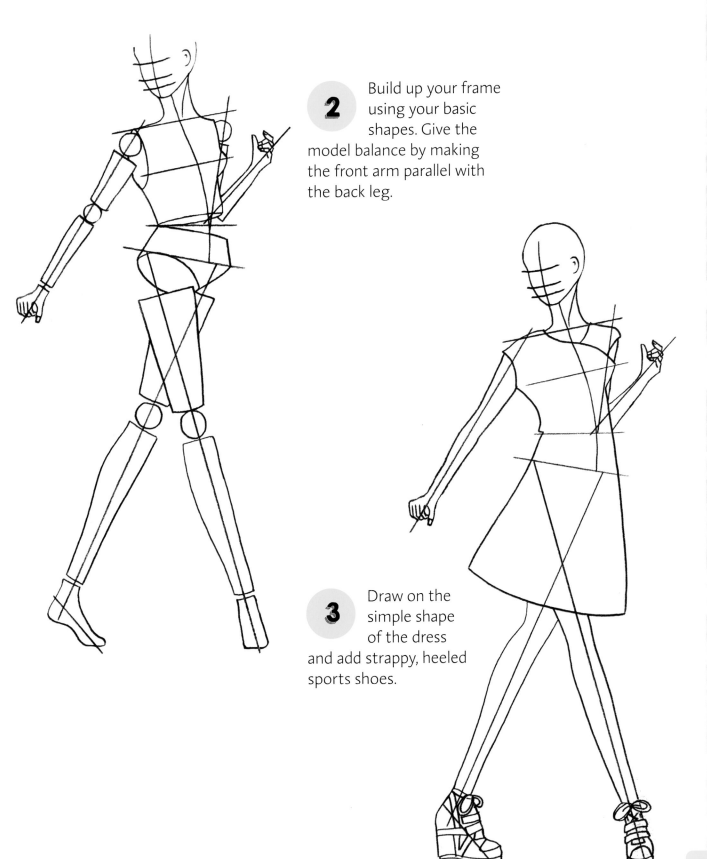

2 Build up your frame using your basic shapes. Give the model balance by making the front arm parallel with the back leg.

3 Draw on the simple shape of the dress and add strappy, heeled sports shoes.

Geometric Collection

4 A neat bun hairstyle works well with this outfit. Keeping the hair away from the shoulders shows off the shape of the neckline.

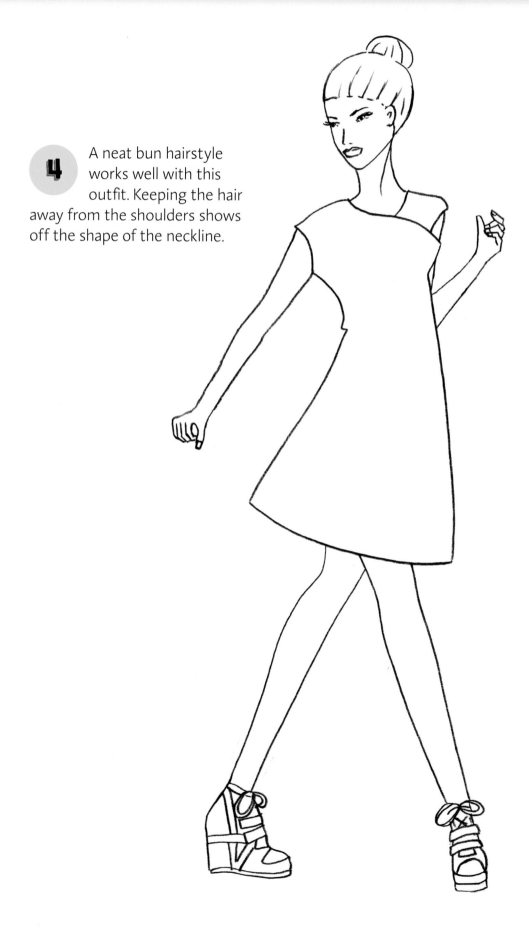

5 Work up the geometric shapes on the dress, complementing them with a geometric style tote. Swing the bag out to the side to give the model movement.

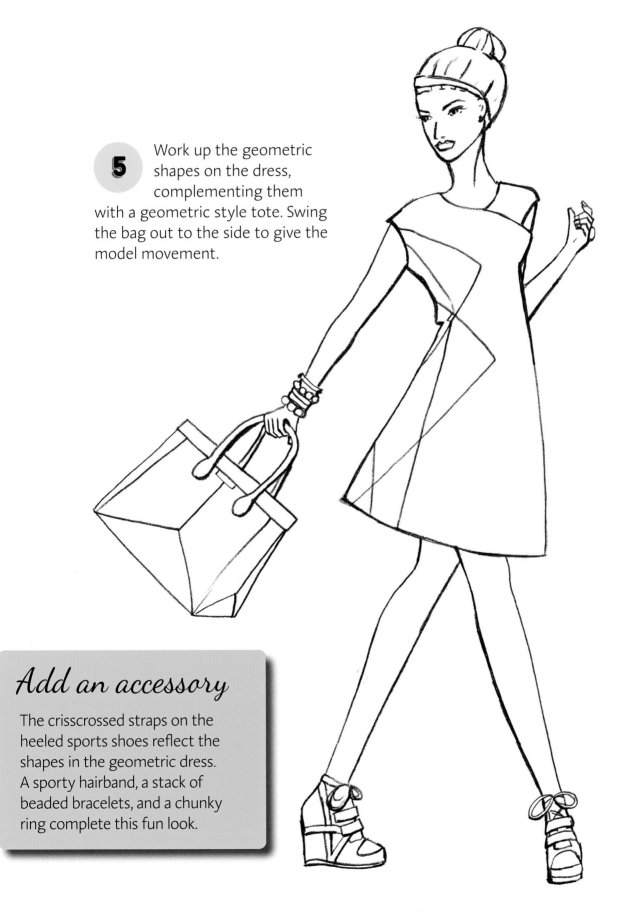

Add an accessory

The crisscrossed straps on the heeled sports shoes reflect the shapes in the geometric dress. A sporty hairband, a stack of beaded bracelets, and a chunky ring complete this fun look.

Geometric Collection

6 Add the ink to your pencil drawing. Working over the lines, add thicker strokes where the shadows fall under the bag and skirt and around the neckline and torso.

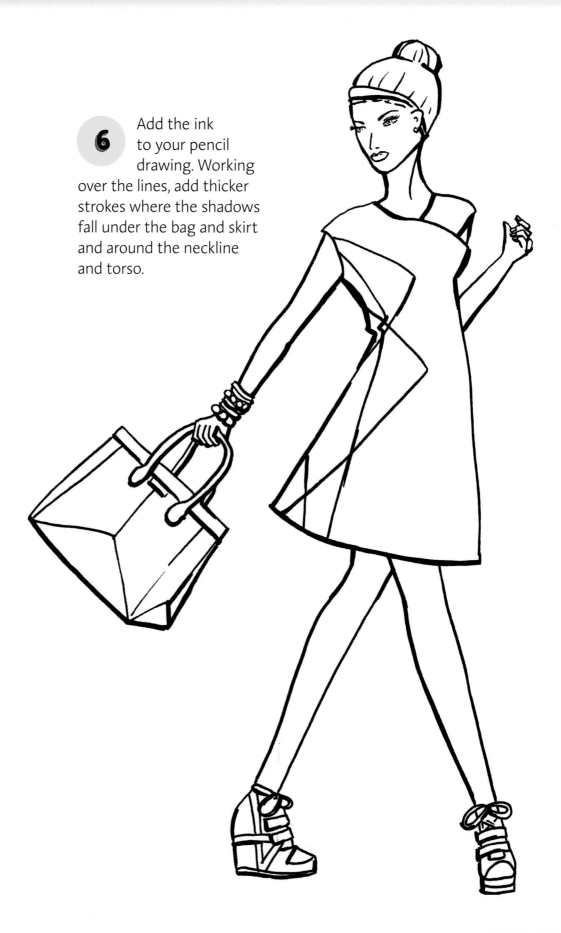

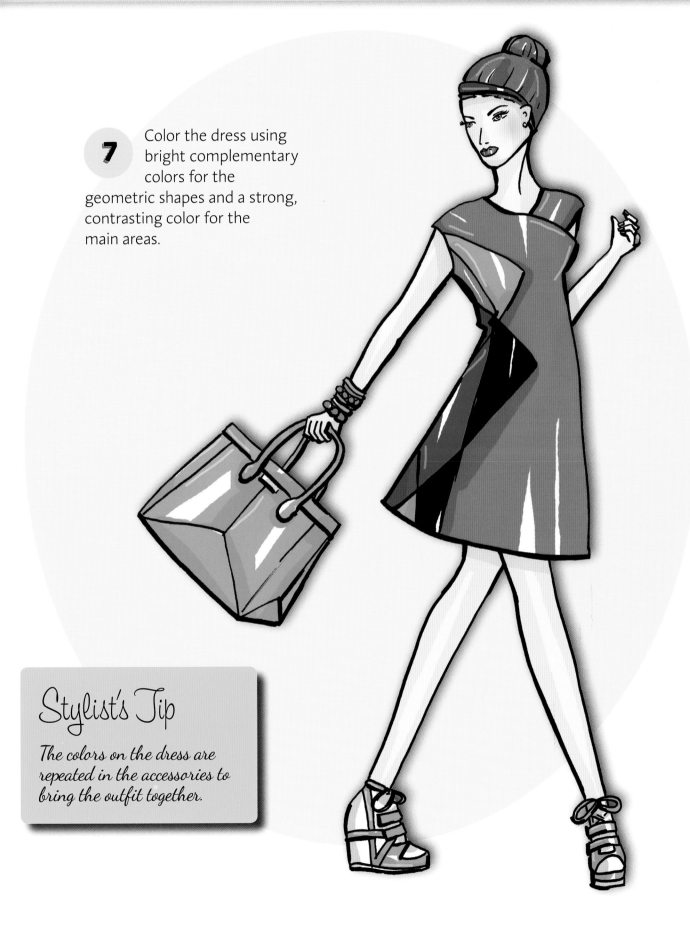

7 Color the dress using bright complementary colors for the geometric shapes and a strong, contrasting color for the main areas.

Stylist's Tip

The colors on the dress are repeated in the accessories to bring the outfit together.

GEO PANTS

Take the geo trend to another level with these sensational skinny pants. Pair them with simple accessories and let the legs do the talking!

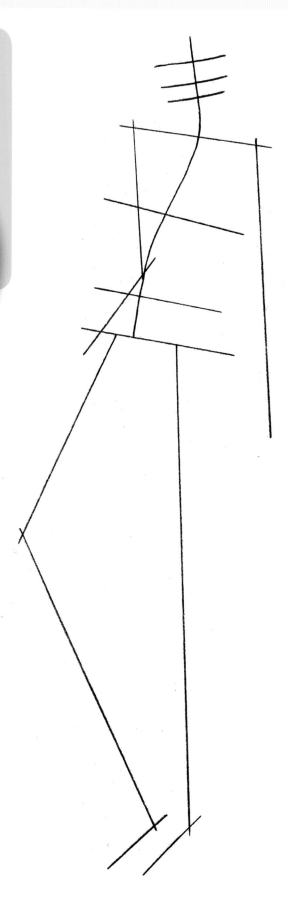

1 Start by drawing the frame of your model. Create a laid-back pose using a soft curve for the body going up into the tilt of the head.

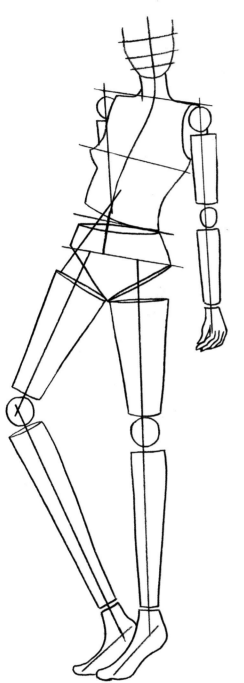

2 Work up the structure of the body, using cylinder shapes for the limbs and balls for the joints.

3 Draw in the lines of the outfit. Follow your frame for the T-shirt and pants. Add wedge-heeled ankle boots.

Geometric Collection

4 Time to add the hairstyle and facial features. A soft side ponytail will enhance the curve of the body. Add pocket details to the T-shirt and pants.

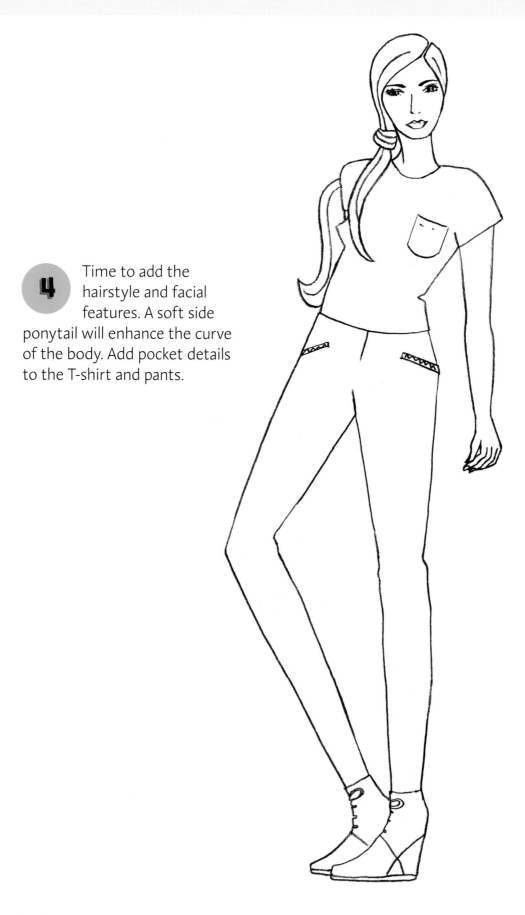

5 Create the geometric print on the pants using a sharp pencil to add angled lines. Add a large handbag and an oversized watch. Top off the outfit with a statement wide-brimmed hat.

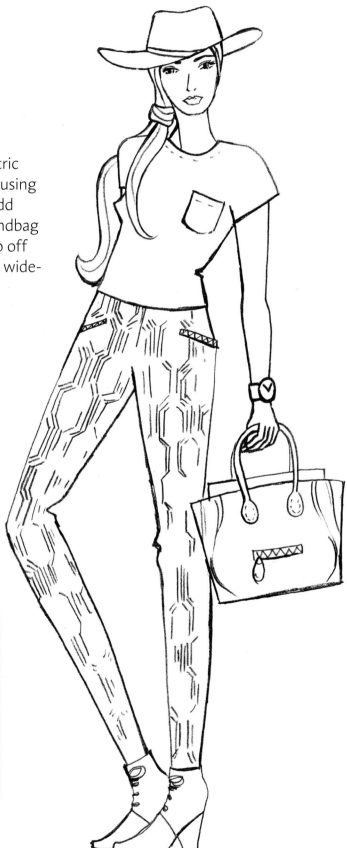

Add an accessory

Make sure you keep the bag, shoes, and top very plain so that they don't draw attention away from the loud geometric print on the pants.

Geometric Collection

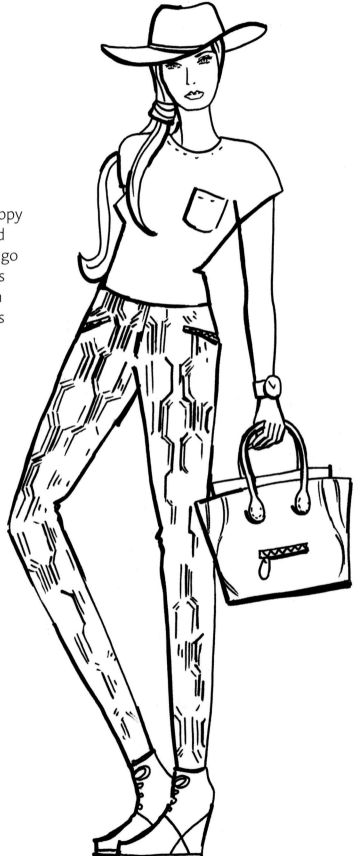

6 When you are happy with your finished drawing, start to go over it in ink. Use thin lines for the geometric print on the pants. Use thicker lines under the bag and around the rim of the hat.

7 Color the final picture in red, white, and blue, using red for the hat to make a real statement. Complete the look with a black patent bag and boots. Add a black band to the hat to tie it together with the other accessories.

Stylist's Tip

Using a really strong color for the hat helps to balance the busy print of the pants.

Geometric Collection

MAXI DRESS

Steal the show with this gorgeous split-fronted maxi dress, which brilliantly combines elegance, drama, and effortless style.

I Use straight lines to create a casual pose for your model. Balance the figure by drawing the opposite arm and leg at a parallel angle.

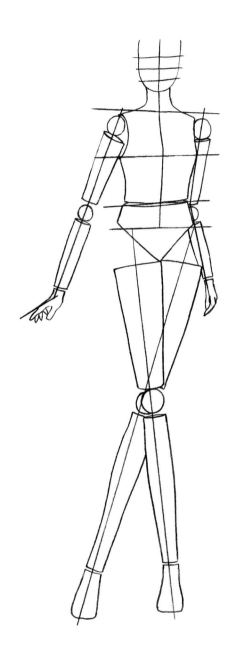

2 Work up the pose, using the basic cylinder and ball shapes to construct the body.

3 Add the figure-hugging shape of the dress to the frame. Draw the split at the front and the billowing train at the bottom. Add some strappy thong sandals.

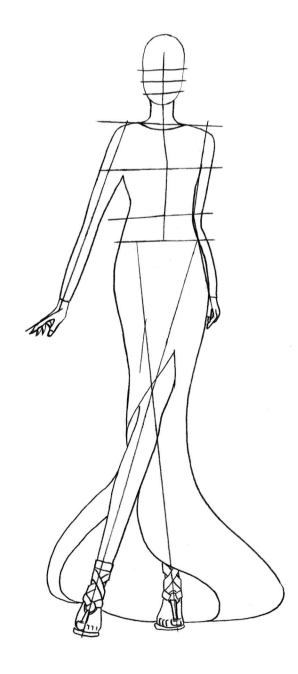

Geometric Collection

4 Remove your pencil lines. Add the facial features and hairstyle. A long, loose style tumbling over the shoulders works well with the flowing lines of the dress.

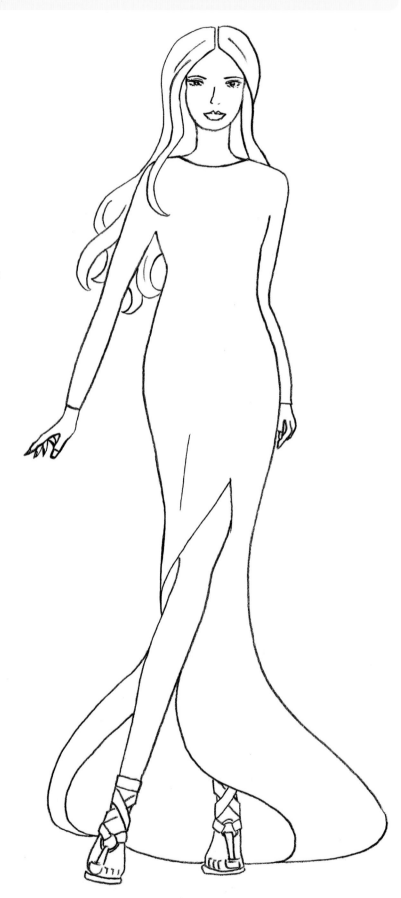

5 Now to add the geometric pattern. Draw diagonal lines, following the natural shape of the body. A large necklace completes the look.

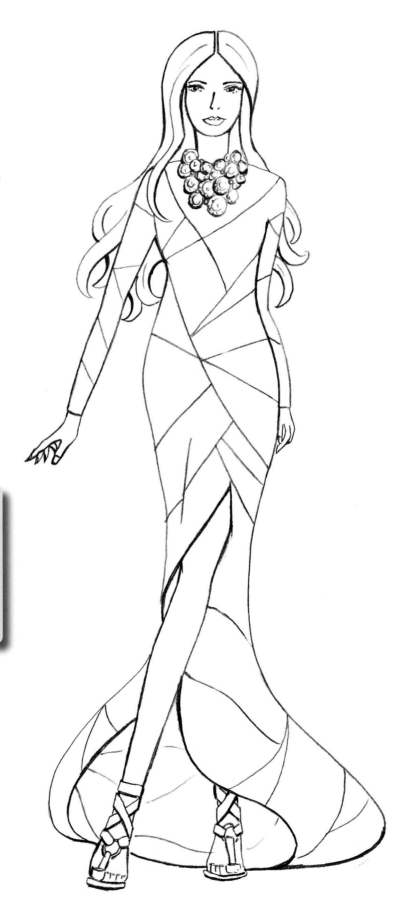

Add an accessory

The statement necklace contrasts well with the simple lines and geometric shapes on the dress.

Geometric Collection

6 When you are happy with the pencil, it's time to ink your drawing. Use thin lines for the pattern on the dress and the necklace detail. Use a heavier line to emphasize the split at the front and the curvy outline.

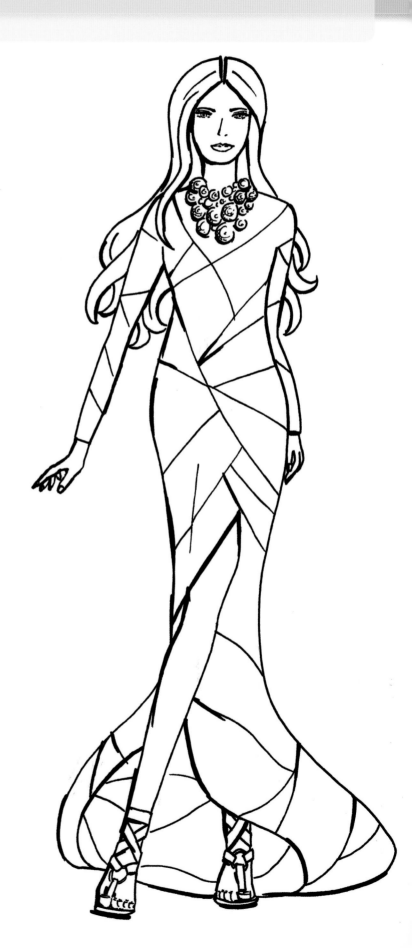

7 Finally add the color. Use a subtle palette of pale blue, gray, and purple. Color the necklace gold for a touch of glamour.

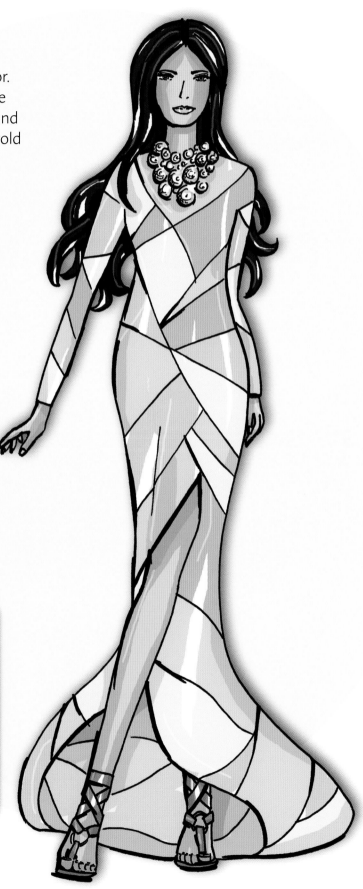

Stylist's Tip

The diagonal straps on the sandals complement the geometric pattern, but their tan color does not detract from the dress itself.

Geometric Collection

STYLE CARDS

Geometric prints and designs can be found anywhere—on shoes, bags, or jewelry. Whether you are dressing up or keeping things casual, shapes can make any outfit sensational!

Accessories

Get the geometric style with jewelry you can wear every day or for a special occasion.

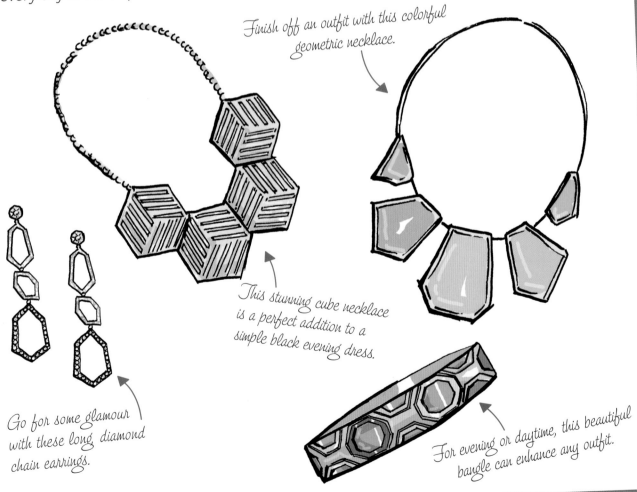

Finish off an outfit with this colorful geometric necklace.

This stunning cube necklace is a perfect addition to a simple black evening dress.

Go for some glamour with these long diamond chain earrings.

For evening or daytime, this beautiful bangle can enhance any outfit.

Bags

Show off a great geometric print on a large holdall or a small evening bag.

This wonderful geometric gold purse gives any outfit a touch of glamour.

Give any outfit some zing with this geo-style clutch.

Get the look every day with this totally brilliant tote.

Shoes

Take the geometric style to the tips of your toes with funky footwear.

Make a statement with these strappy heeled sandals.

Get sporty with these mixed-fabric sneakers.

Get into geometric mode with these multicolored nails.

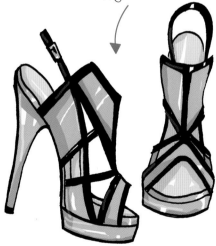

OVERSIZED COLLECTION

Move over super skinny and make room for oversized! Going large with shape and style gives classic pieces a real wow factor—especially when they are teamed with chunky accessories.

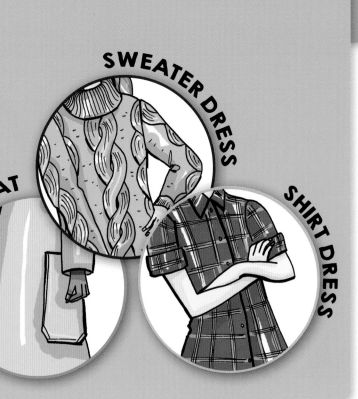

SWEATER DRESS

OVERSIZED COAT

SHIRT DRESS

OVERSIZED COAT

Go for maximum impact on the catwalk with this oversized duster coat. Using pale, soft colors keeps the look light and feminine.

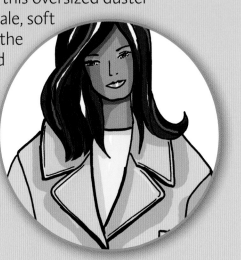

1 For this outfit, keep the model front facing and the pose open. Draw the legs and arms away from the body.

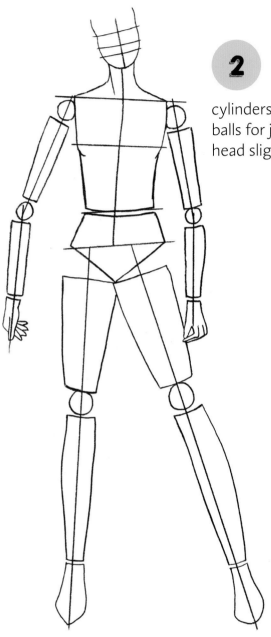

2 Make the body shape using the cylinders for limbs and balls for joints. Tilt the head slightly.

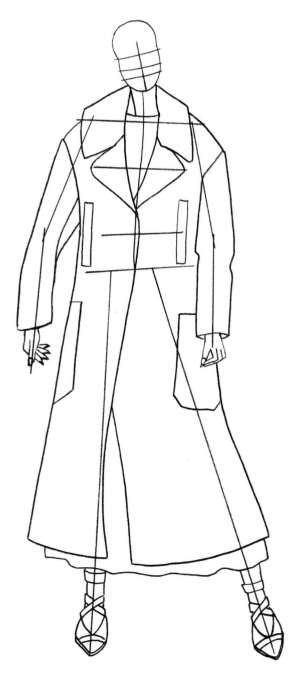

3 Draw the oversized coat onto the frame. Keeping the coat closed hides the under garments making the coat the statement piece. Draw on the oversized pockets and collar to give the coat balance. Add strappy shoes to finish off the outfit.

Oversized Collection

4 Remove the frame lines and draw the facial features. Give the model a flowing, mid-length hair style. Soften the coat style by laying the hair over the collar.

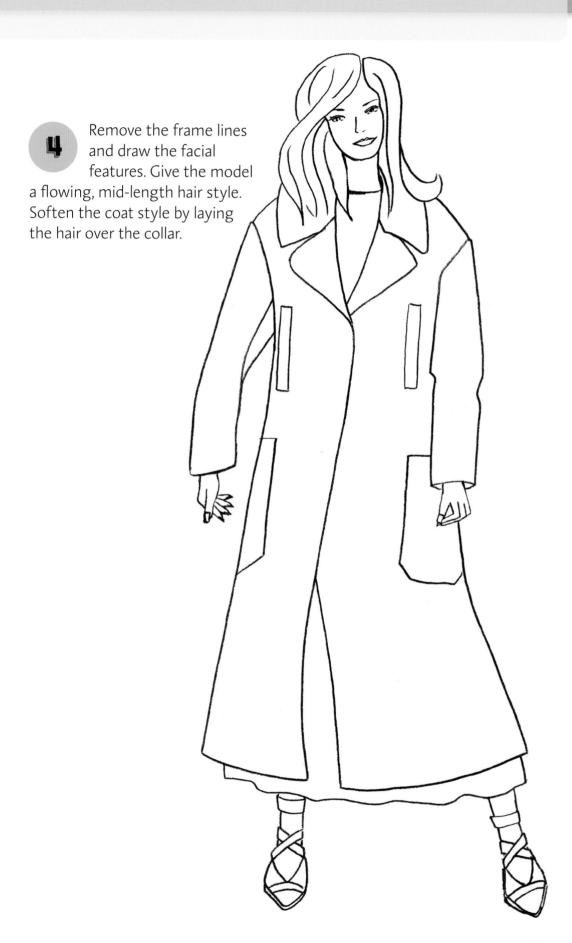

5 Add an oversized bag to your outfit, keeping it under the arm to help show off the statement coat. Give more definition to the coat, using a soft, thin line for the seam detail.

Add an accessory

Give the handbag a chain strap detail using the pebble texture technique. This contrasts with the outfit's pared-back style.

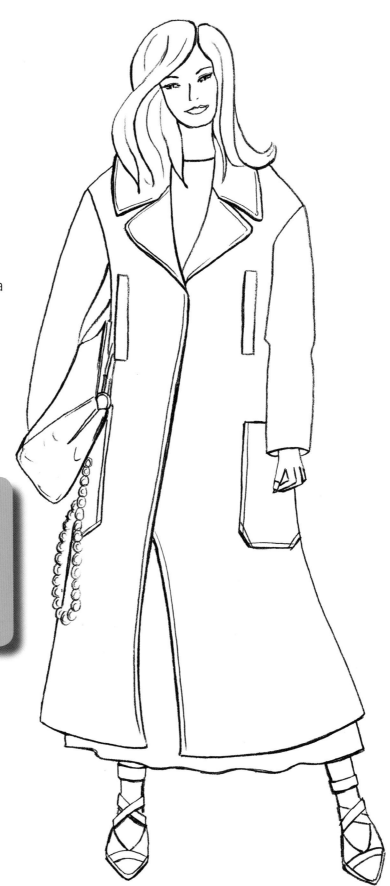

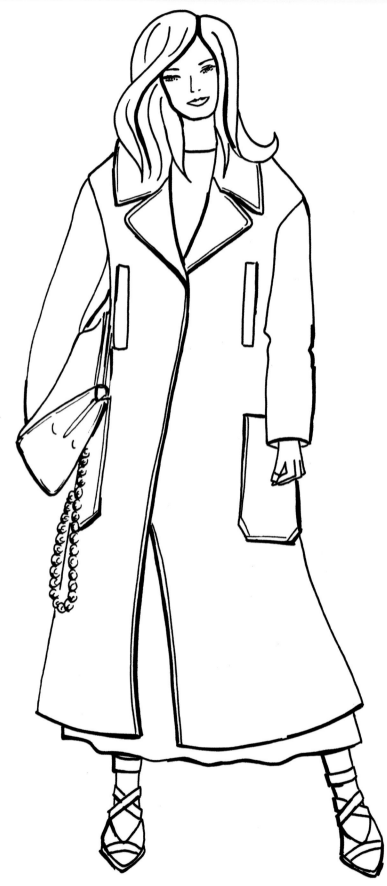

6 Now ink your picture. Use thick lines around the outside of the coat and under the collar and opening flaps. Thin lines work well for the seam detail.

7 Use a soft, dusty pink for the main coat color. Enhance this with a cream dress underneath.

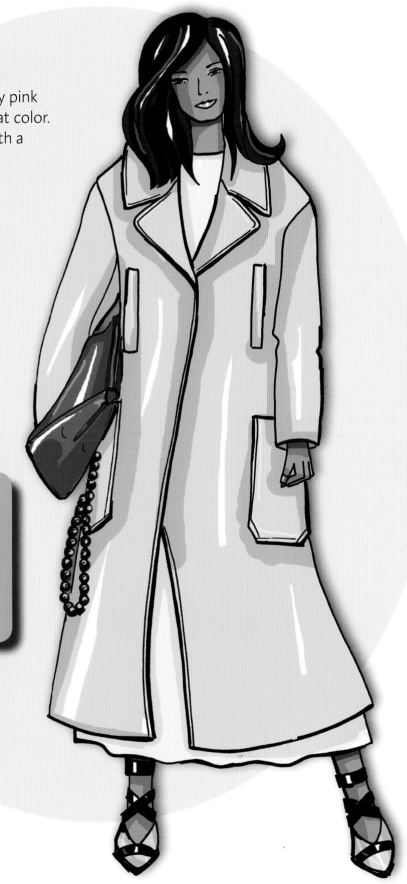

Stylist's Tip

The deep eggplant of the handbag and shoes contrasts well with the pale, milky shades used in the main pieces.

SWEATER DRESS

Get cozy in this chunky sweater dress. Keep the color plain to show off the creative oversized knit pattern. Work the softness of the knit with high shine accessories.

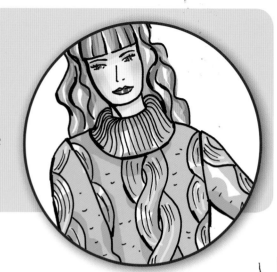

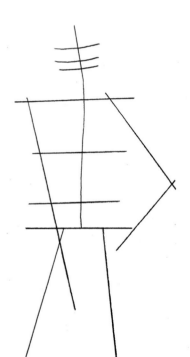

1 For this statement piece give your frame smooth lines for a casual pose. Position one arm across the body, ready to add the handbag later.

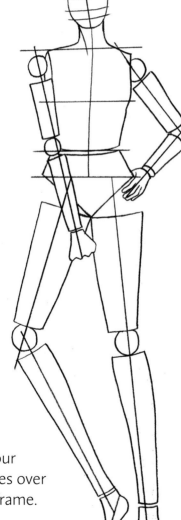

2 Draw in your basic shapes over the body frame.

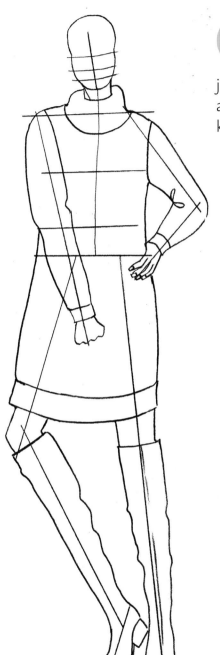

3 Pencil in the sweater shape. Take care to follow the line of the body but still give the jumper shape some chunkiness. Add a wide roll neck and finish off with knee boots.

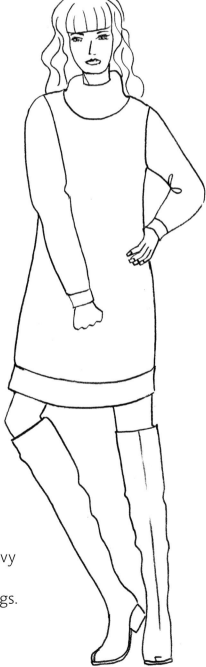

4 Add facial features to your model. Using wavy lines, create a curly hairstyle with heavy blunt bangs.

Oversized Collection

5 Now it's time for the detail. Draw interweaving wavy lines to create the cables in the knit. Draw thin, parallel lines on the neck, cuffs, and bottom edge for the ribbing. Add creases to the front of the knee boots and an oversized bag to complement the outfit.

Add an accessory

The oversized bag is worked up with plenty of interesting details, such as studs, labels, beads, and chains.

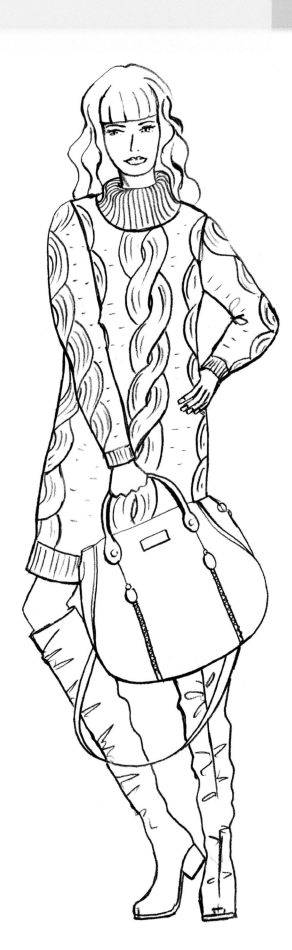

6 Time for the ink. Work over the pencil, paying attention to where there will be shadows—under the roll neck, under the arms, and through the hair.

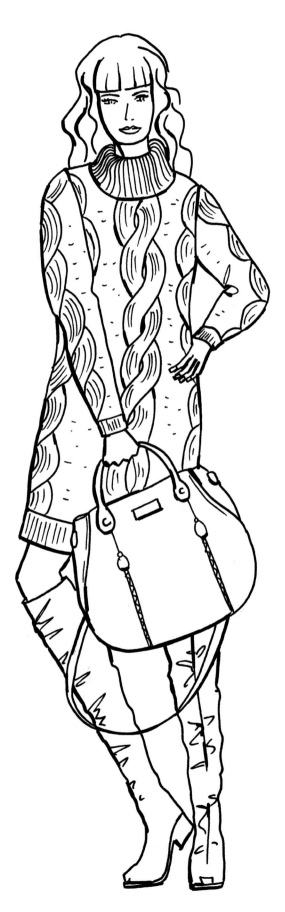

7 The final step is the color. Use a pale aqua blue for the sweater to complement the model's auburn hair. Make the bag a warm brown color with gold details. Add lots of highlights to show the gathering at the front of the boots.

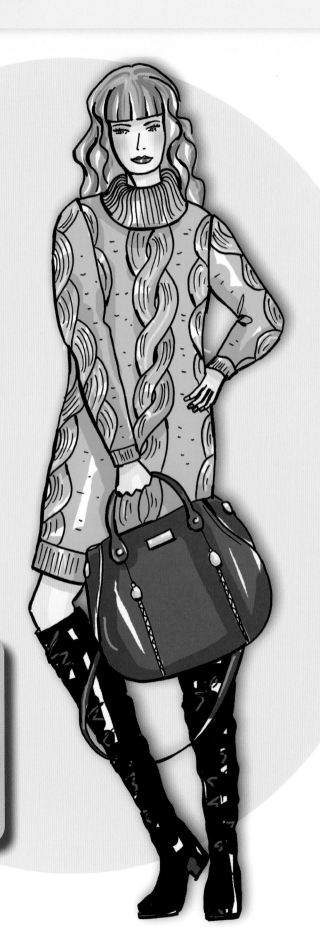

Stylist's Tip

Use plenty of subtle shading on the sweater design when you are coloring. This will help create the chunky texture of the knit.

SHIRT DRESS

This fantastic oversized shirt dress is a great addition to any wardrobe. Worn with simple accessories, the shirt says it all.

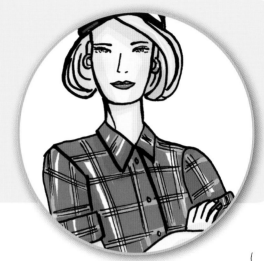

1 Draw a relaxed pose for this model. Gently bend one knee and cross the arms.

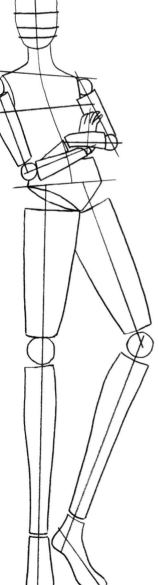

2 Add your body shape, taking care to tuck one of the hands under the elbow of the other arm.

Oversized Collection

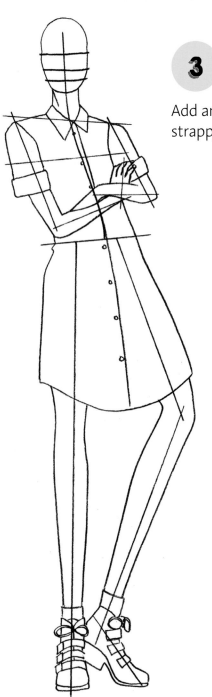

3 Draw the outline of your oversized shirt over the frame. Add ankle socks and chunky, strappy boots.

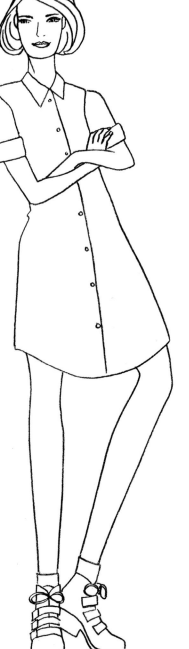

4 Now for the facial details and hairstyle. Frame the face by drawing a soft bobbed style using curved lines.

5 Use a cross-hatching technique to draw the checked pattern on the shirt. Take care to follow the shape of the body. Use pebble texture for the small shirt buttons.

Add an accessory

A soft beanie hat and simple hoop earrings top off this outfit without detracting from the statement shirt.

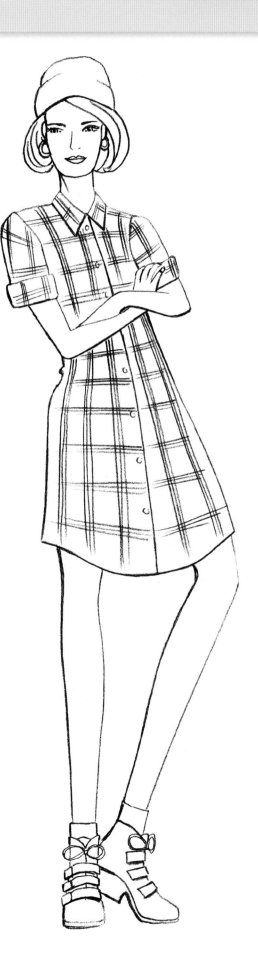

Oversized Collection

6 Start working up your pencil with ink. Use a light pencil stroke for the check detail on the shirt. Make the lines thicker around the outline, collar, and shirt opening.

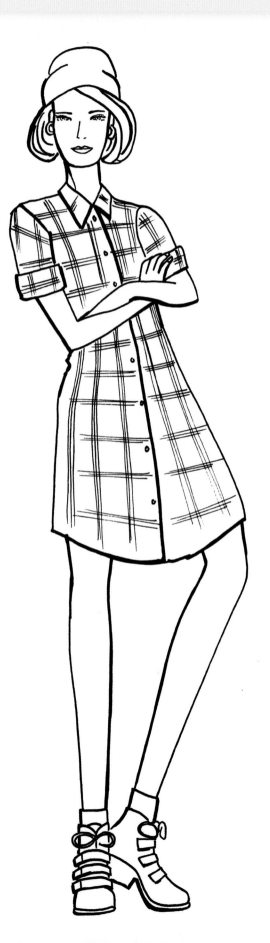

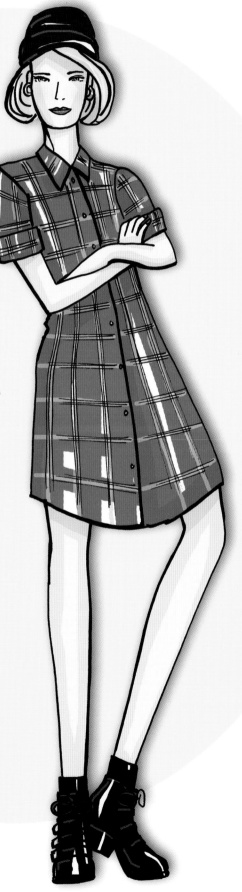

7 Use a bright red for the shirt with black and yellow check detail. The black hat balances the chunky black boots and draws our eyes to the colorful shirt.

Stylist's Tip

The model's blond hair and gold earrings bring out the yellow stripe in the check print. The red lipstick complements the strong shirt color.

Oversized Collection

STYLE CARDS

The oversized look is all about thinking big and beautiful. Enhance any outfit with some great accessories. Pick a few key pieces that pack plenty of oversized style.

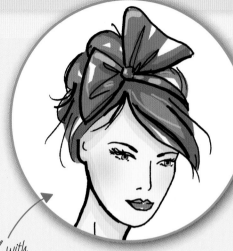

Add "wow" with oversized hair accessories, like this big hair bow.

Jewelry

For an easy way to get the look go for jumbo gems and giant cluster rings.

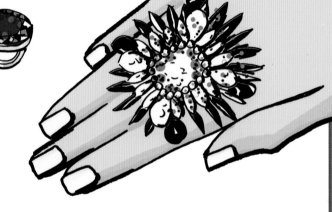

Really stand out with a gorgeous dress ring. Perfect to add glamour to any evening outfit.

Shoes

The oversized style works whatever the weather. Keep it big and chunky with sandals or boots.

Super thick strappy sandals are a great style for summer.

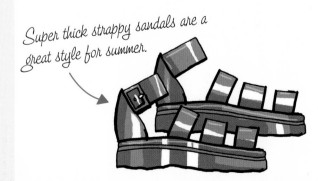

Make a statement with these chunky-soled boots.

Bags

Whether it is for evening or daytime, taking your bag to the max can really make this look work.

Team this oversized bag with some chunky boots.

Add some sparkle to your evening outfit with this big sequined clutch.

An oversized holdall works the look in the daytime.

Accessories

Jewelry can be used to make your outfit look sophisticated and stylish.

Keep it simple with an oversized bracelet in a strong color.

Sequined scrunchy.

Make a statement with studded cuffs and bangles.

Go large with this stunning chunky chain and gold dangly earrings.

Add some glitz with this multicolored beaded bracelet.

STREET STYLE COLLECTION

Great fashion inspiration can be found everywhere you go, from the colorful streets of Tokyo to the bustling New York sidewalk. Get out there and steal some cutting-edge street style from around the globe!

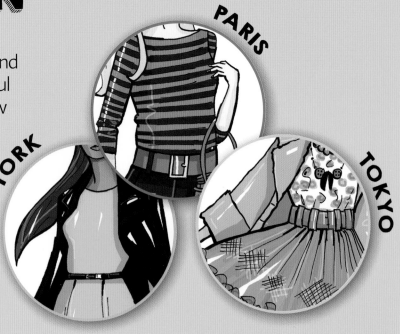

PARIS

NEW YORK

TOKYO

NEW YORK

You might need your shades for this sunny, taxi-yellow dress. Wear it with stylish black accessories and you will be stopping traffic as you step out in style.

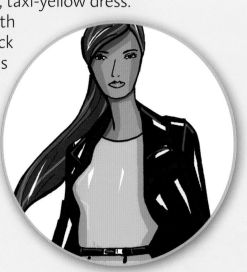

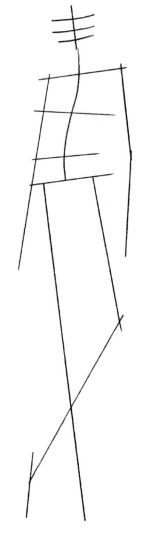

1 Create a relaxed pose with a crossed leg, curved body, and tilted shoulder line.

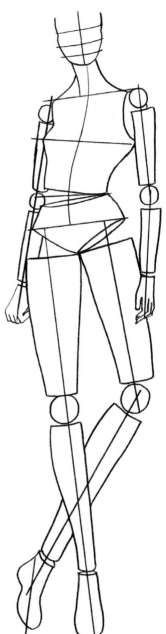

2 Build up your frame by adding the cylinder shapes for the limbs and ball shapes for the joints.

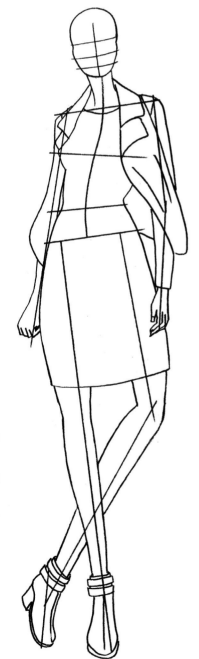

3 Add the shape of the outfit to your body frame. Draw a simple shift dress, keeping the look casual by adding a jacket over the shoulders. Add stylish strappy ankle boots.

4 Remove the frame lines and draw in the model's face and hairstyle. Sketch a high ponytail flicking out to the side to give it movement.

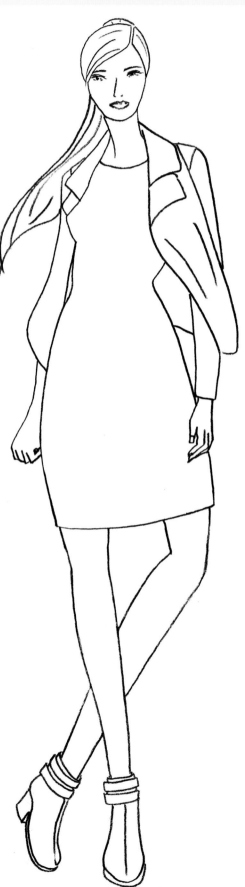

5 Time to add the accessories. Give the dress a narrow belt to nip in the waist. An oversized bag, watch, and ring finish off the city-chic look.

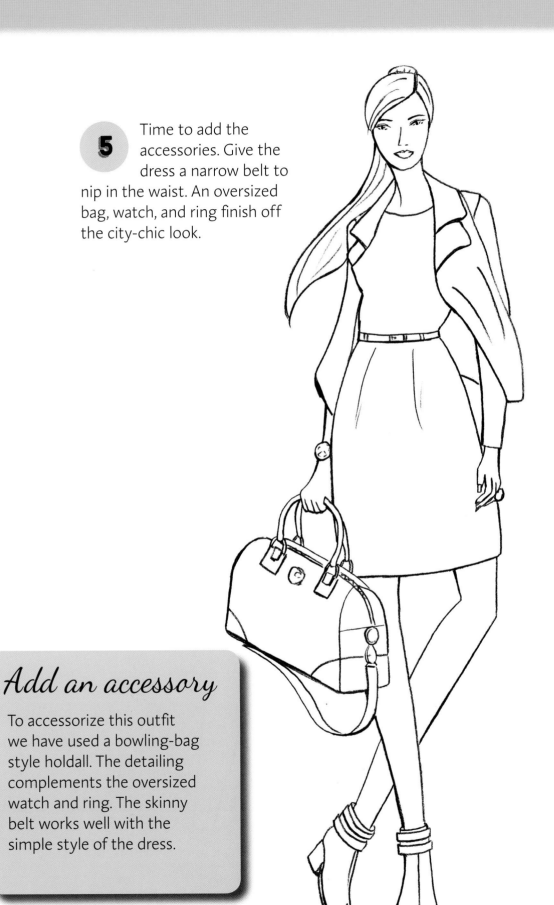

Add an accessory

To accessorize this outfit we have used a bowling-bag style holdall. The detailing complements the oversized watch and ring. The skinny belt works well with the simple style of the dress.

93

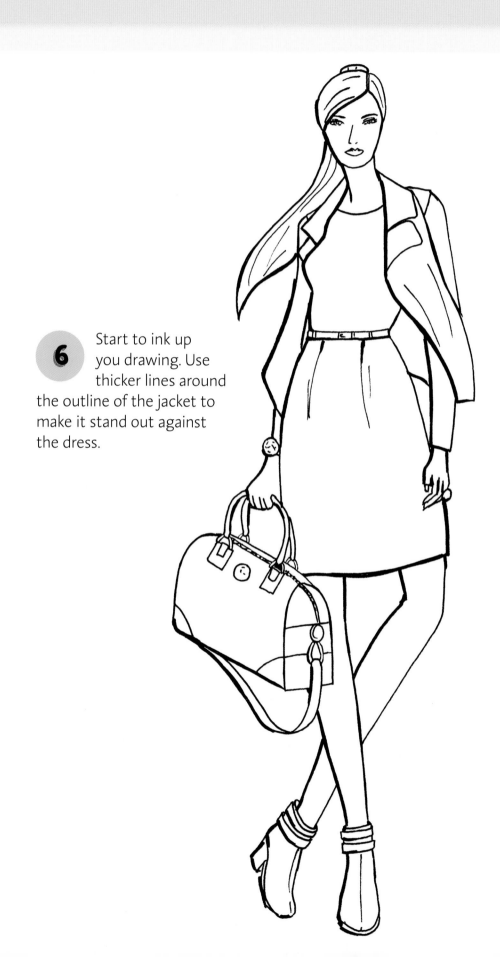

6 Start to ink up you drawing. Use thicker lines around the outline of the jacket to make it stand out against the dress.

7 A bright yellow works really well for this statement dress. Using black for all the accessories makes the dress really stand out.

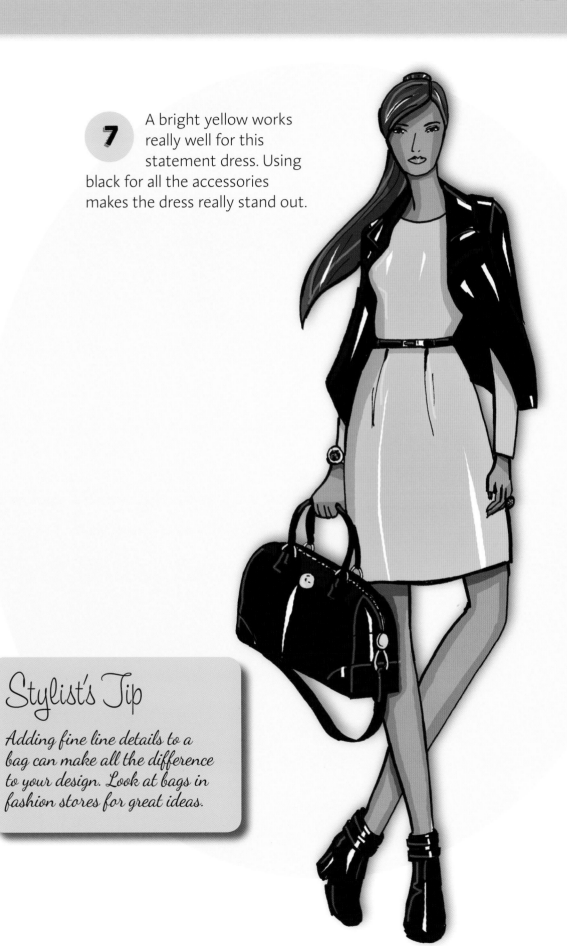

Stylist's Tip

Adding fine line details to a bag can make all the difference to your design. Look at bags in fashion stores for great ideas.

PARIS

Update classic Parisian stripes with great contrasting colors. Team this look with electric blue accessories to get the ultimate in smart-casual summer style.

1 Draw your frame, using straight lines for the limbs and a soft curve for the body.

2 Add the balls for joints and the cylinders for the limbs. Roll one leg out to give the model some shape.

3 Draw the outline of your outfit onto your model. Draw simple shapes for the top and pants. Contrast these by adding detailed ankle-tie strappy sandals.

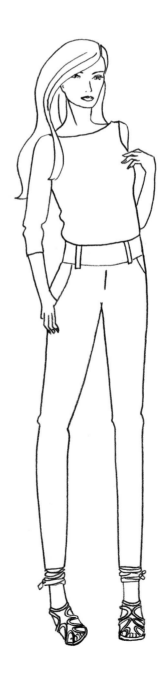

4 Create your model's hairstyle and facial features. Long hair swept over to the side works well with this outfit.

5 Accessorize your outfit with a wide belt and a slouchy handbag hung casually from her elbow. Draw horizontal stripes across the model's top using long and short lines that disappear in places to show where the light falls. Make the stripes on the sleeves slightly curved to follow the contours of the arms.

Add an accessory

To keep the feeling casual but chic we have chosen a small boho bag to feature on this outfit. The tassel detail works well with the ankle straps on the sandals.

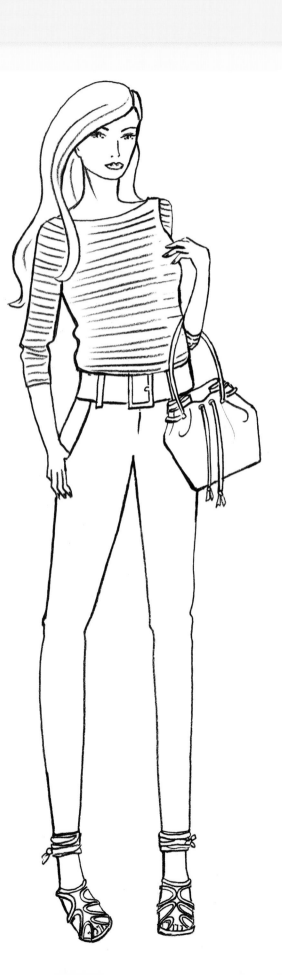

6 Use thick lines to outline the pants, top, bag, and belt, and thin lines for the stripy top and sandal straps. A thick outline where the hair falls across the face gives the appearance of volume.

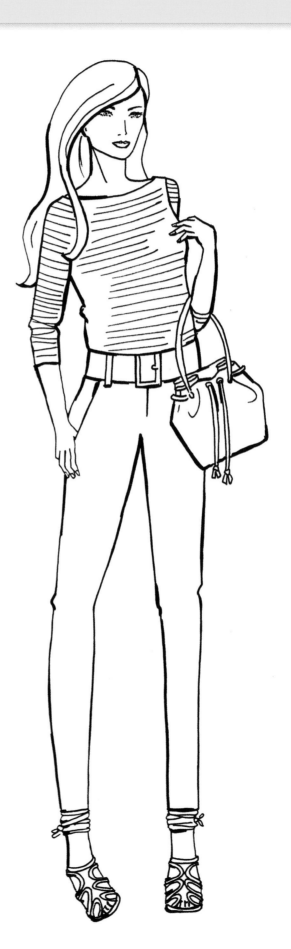

7 Color your model using mainly navy with a contrasting pink for the stripes. Lighten up the outfit by using electric blue for the accessories.

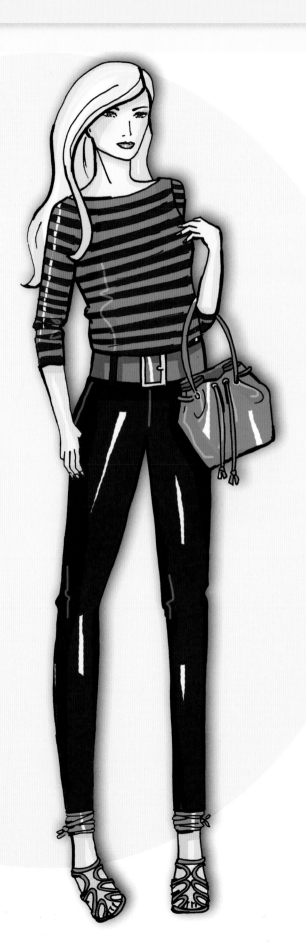

Stylist's Tip

Add shadow across the neck and face to show how the model's thick hair overhangs. Highlights on the top and pants give them more shape.

TOKYO

You can't help but have fun with this outfit. Combine patterns and textures with quirky accessories to create an offbeat street style that has a charm all of its own.

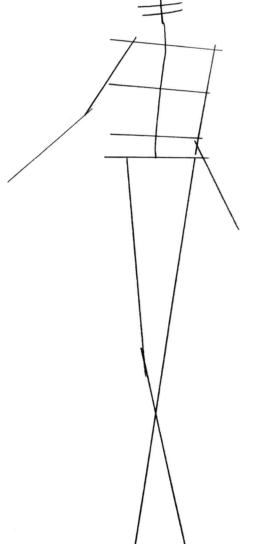

1 Use fluid lines for this frame. Gently open out the arms and cross the legs for a girly pose.

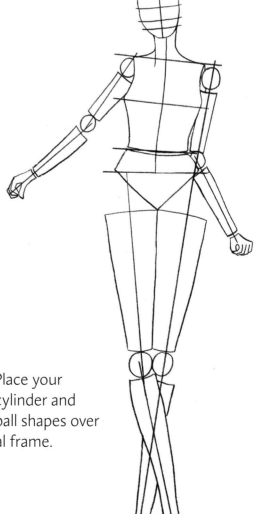

2 Place your cylinder and ball shapes over your initial frame.

Street Style Collection

3 Add the shape of the outfit onto your model. Use a scribble stroke for the ruffled detail around the hem of the skirt. Put the hem of the skirt into one hand to show off its shape. Draw a coat with a large collar and cuffs falling behind the skirt. Finish off the outfit with a chunky belt, socks, and platform shoes.

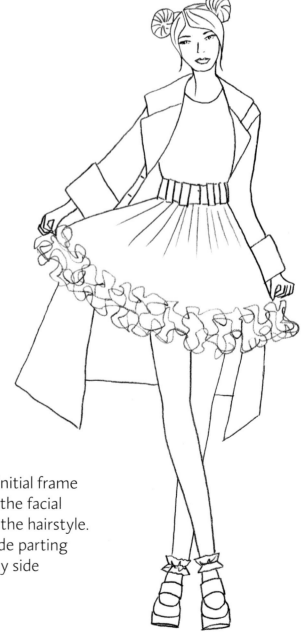

4 Take off the initial frame and work up the facial features and the hairstyle. A soft fringe with a side parting looks great with quirky side topknots.

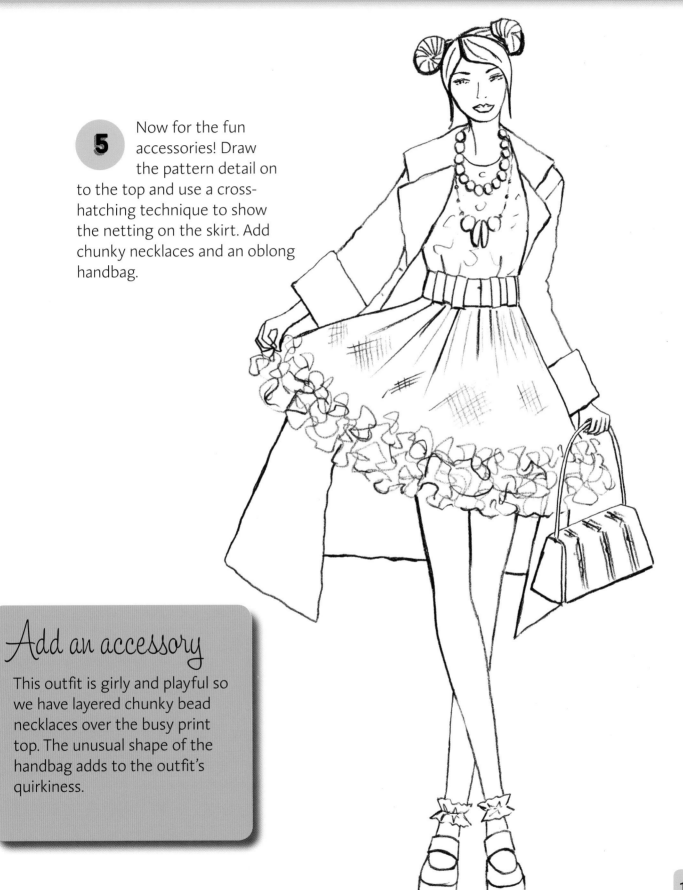

5 Now for the fun accessories! Draw the pattern detail on to the top and use a cross-hatching technique to show the netting on the skirt. Add chunky necklaces and an oblong handbag.

Add an accessory

This outfit is girly and playful so we have layered chunky bead necklaces over the busy print top. The unusual shape of the handbag adds to the outfit's quirkiness.

6 Now for the ink. Use thick and thin scribble strokes for the skirt hem. Add a thicker, slightly wobbly line around the coat to give the impression of a faux fur fabric. Keep the lines thin for the cross-hatching on the net skirt and the print detail on the top.

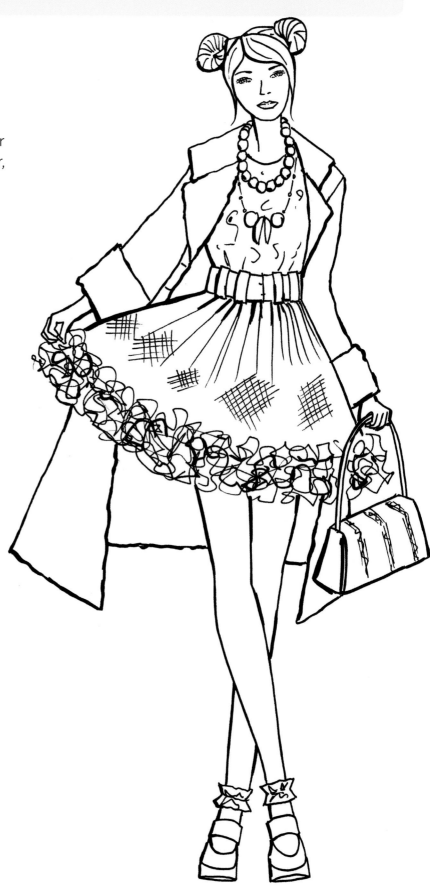

7 For this fun outfit, combine zingy shades of pink and orange with a soft blue. These colors are set off by the crisp white of the top and ankle socks.

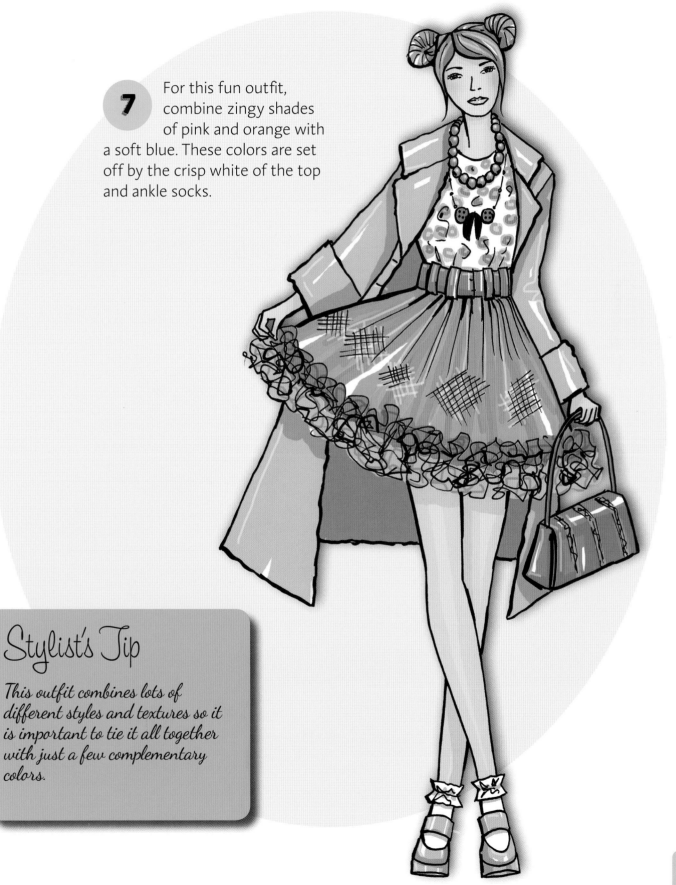

Stylist's Tip

This outfit combines lots of different styles and textures so it is important to tie it all together with just a few complementary colors.

Street Style Collection

STYLE CARDS

World-class fashion designers are inspired by the exciting street styles they discover around the world. You can take some tips from top city chic without even having to leave home!

New York street style

This look is sharp, sophisticated, and exciting. To really get the look try out some of these ideas.

A shaggy bob is great for New York street style.

Taxi-yellow gloves look great with a black jacket.

Get the look with this super-chunky scarf.

Top off your outfit with a gangster-style hat.

Work the sidewalk in these killer heels.

Finish off the look with a neat manicure.

Tokyo street style

Stand out from the crowd and step out in Tokyo style. You'll need to be brave—this look is quirky, colorful, and bold!

Get noticed in these super-stripy knee socks.

Wear-if-you-dare this multicolored dip-dye hairstyle.

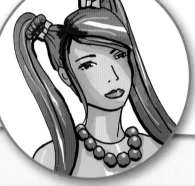

Try some beaded bracelets for a real slice of fun. Stack them up for a really wacky look.

For a cute and quirky touch, have fun with some animal accessories.

Make a statement in red strappy platforms.

Try out these multicolored nail art ideas.

Paris street style

Paris is famous for its fashion, style, and beauty. Here is how to get the look with simple accessories for the perfect Parisian chic.

Enhance your outfit with this pretty neck scarf.

For the ultimate tomboy look, go for the chop with this cute Parisian crop.

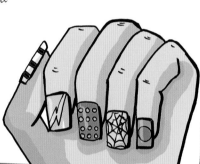

French nail polish gives you a truly sophisticated style.

A Chanel style bag adds unmistakable class to any outfit.

Keep it simple with these pearl drop earrings.

Elegant and chic, these retro heels are enhanced by beautiful bow details.

DESIGN ICONS

This chapter looks at three of the biggest names in couture. The incredible styles that these top designers send down the catwalk are copied around the world. Eventually, their ideas are reproduced by department stores and find their way into a fashion outlet near you!

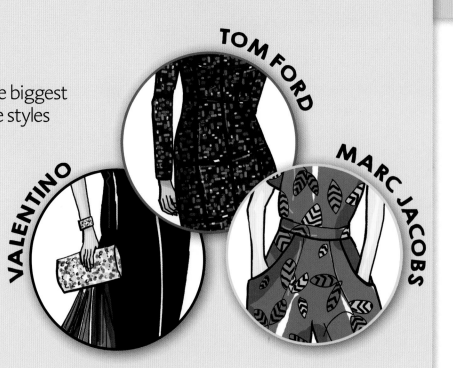

TOM FORD

VALENTINO

MARC JACOBS

VALENTINO EVENING DRESS

Valentino Clemente Ludovico Garavani was born in Italy in 1932. Known simply as Valentino, he has designed clothes for some of the world's most glamorous women, including Audrey Hepburn and Jackie Onassis. This stunning gown went down in history when actress Julia Roberts wore it to accept her Oscar award in 2001. With its clean lines, delicate white detailing, and elegant sweeping train, it's the ultimate in red-carpet glamour.

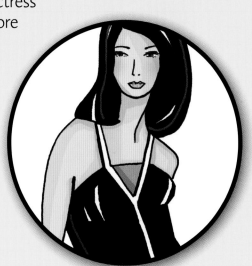

1 A simple relaxed frame works well for this fabulous dress. Tilt the shoulders and the hips in opposite directions and add a strong curve through the torso.

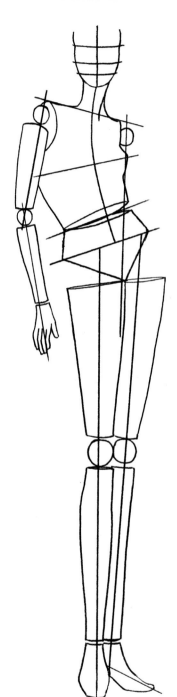

2 Fill out the frame with balls for the joints and cylinders for the limbs.

3 Draw the dress onto your model. Follow the line of the body for the dress shape and the piping down the front. Add a large train, sweeping around the side to the front.

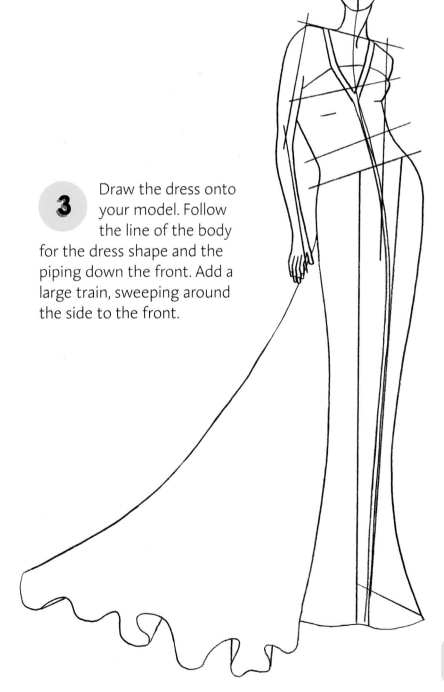

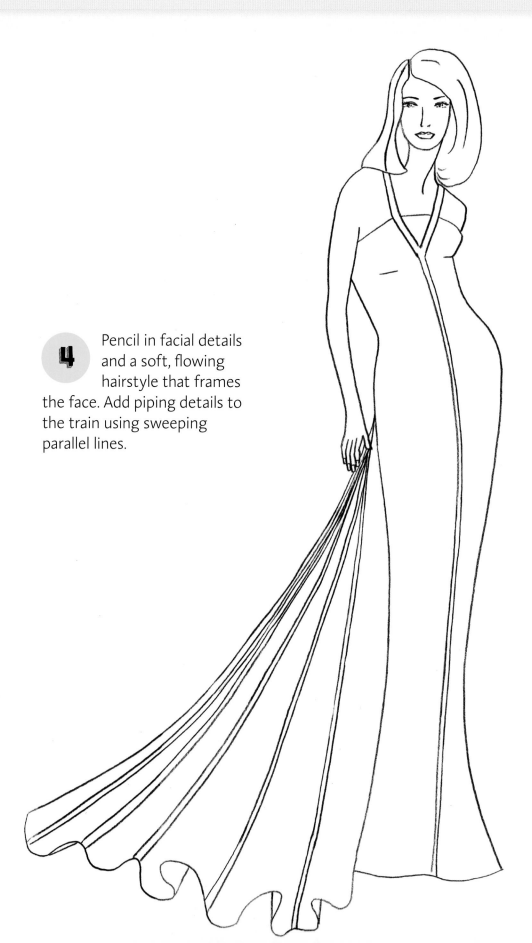

4 Pencil in facial details and a soft, flowing hairstyle that frames the face. Add piping details to the train using sweeping parallel lines.

5 Add a thin, wavy line around the edge of the train to show the different layers of fine fabric. A simple clutch bag and bracelet are all that is needed to accessorize this dress.

Add an accessory

The stippling on the sparkly bag and bracelet creates a great contrast to the smooth lines of the dress.

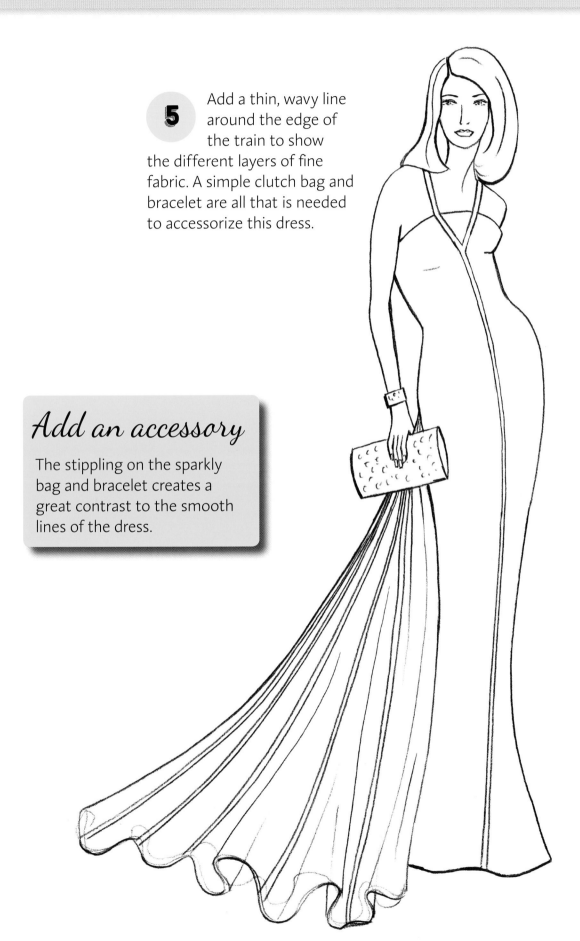

Design Icons

6 When you are happy with your pencil line start to ink your model. Use thicker lines around the neck straps and on the hemline. Use very thin lines around the edge of the train to show the layers of delicate fabric.

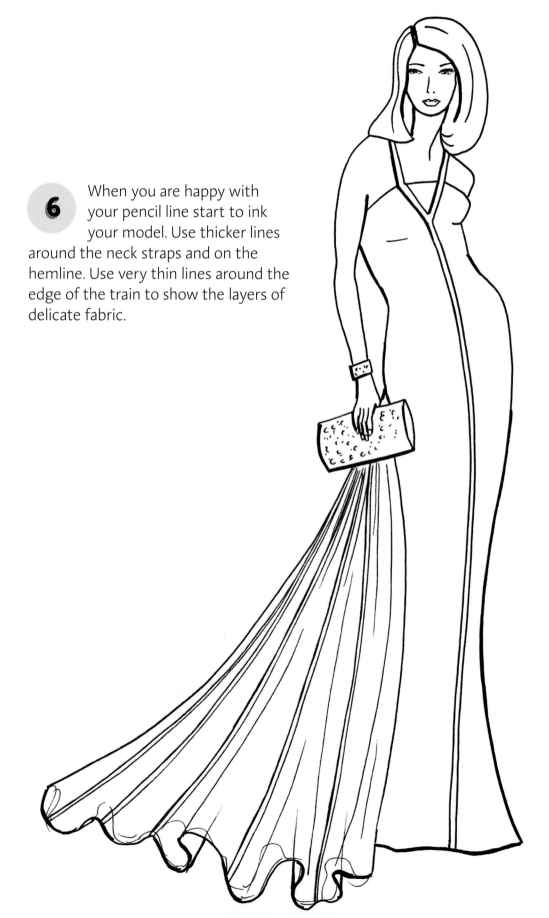

7 Deep black really shows off the beautiful shape of this dress. Leave a few highlights to show the contours of the body. The elegant lines are highlighted even more by the white shoulder straps and the piping that flows through the gown. Complement the gray train with shimmering silver accessories.

Stylist's Tip

Use light and dark grays to show the multiple layers of transparent fabric in the train.

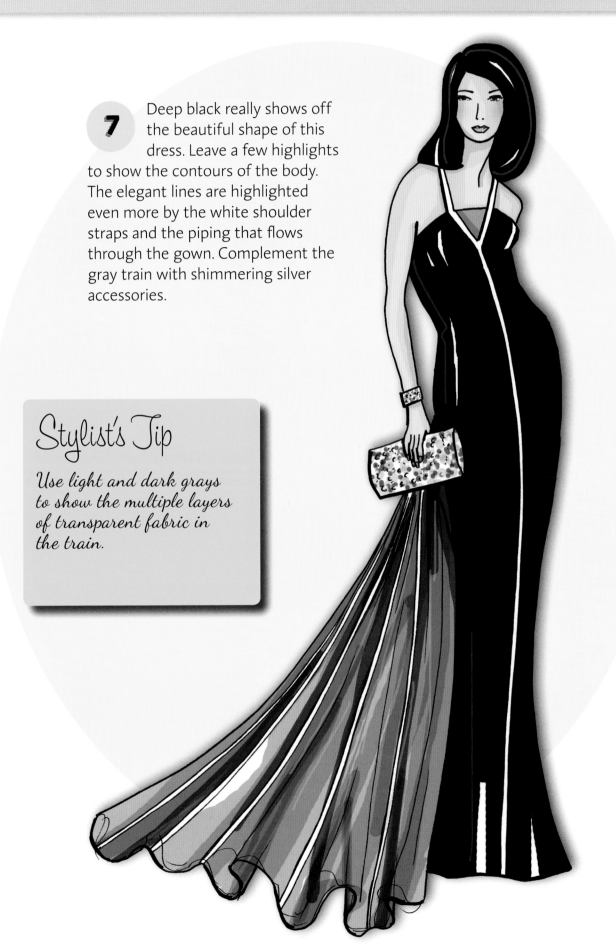

TOM FORD DRESS

American designer Tom Ford is a fashion innovator who shot to success when his strong ideas saved the failing fashion house, Gucci, in the 1990s. Loved by everyone, from royalty to pop princesses, his clothes are famous for their simple elegance. In this dress, he emphasizes the natural curves of the body with structured panels and a mandarin collar.

I Use straight lines with a slight tilt for this walking pose.

2 Draw in the cylinder shapes and balls to fill out the figure.

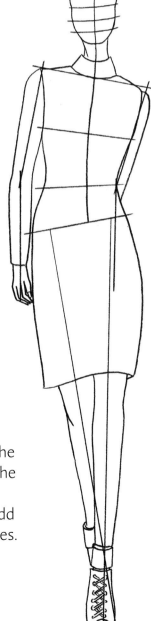

3 Now draw in the outfit, giving the dress a simple shape and high neck. Add heeled lace-up peep-toes.

4 Remove the frame and add the facial features. An oriental-style topknot with short bangs keeps the outline clean and shows off the elegant neckline of the dress.

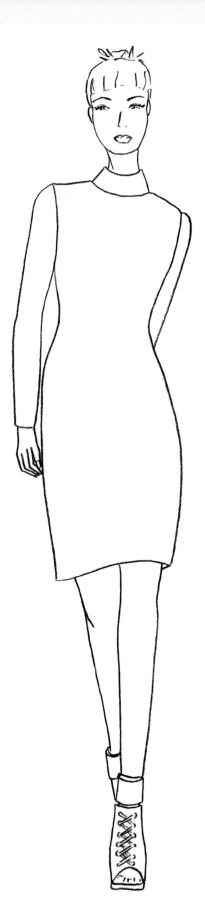

5 Add strap detail with pairs of crisscross parallel lines, taking care to follow the shape of the body. Draw on the print detail using short horizontal and vertical lines.

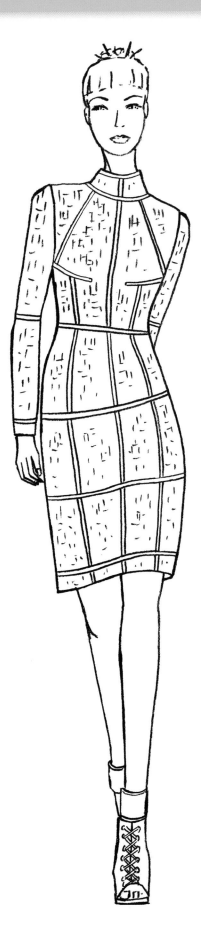

6 Ink up your pencil using thicker lines for the outline of the dress and thinner ones for the strap and print detail.

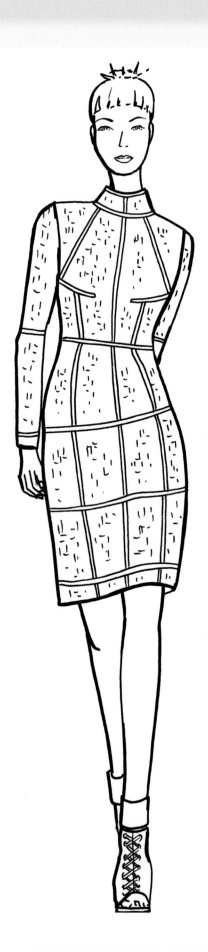

7 Time to color up your Tom Ford dress. Use a range of dusty pinks and dark reds for the dress print. Break up the print with a rich black for the strap detail and the peep-toe sandals.

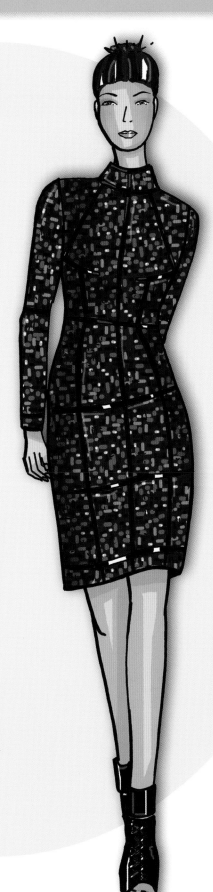

Stylist's Tip

Taking care over the lines of the strap detail can make all the difference to its structured look.

MARC JACOBS JUMPSUIT

Marc Jacobs started his career as a stockboy at a New York boutique, but his passion for fashion has taken him all the way to the top. He now runs his own label with 200 stores in 80 countries. He likes to blend street trends and high couture to create a unique style. This loose floral-print jumpsuit is a great example!

1 Use simple lines for a relaxed, wide-legged stance.

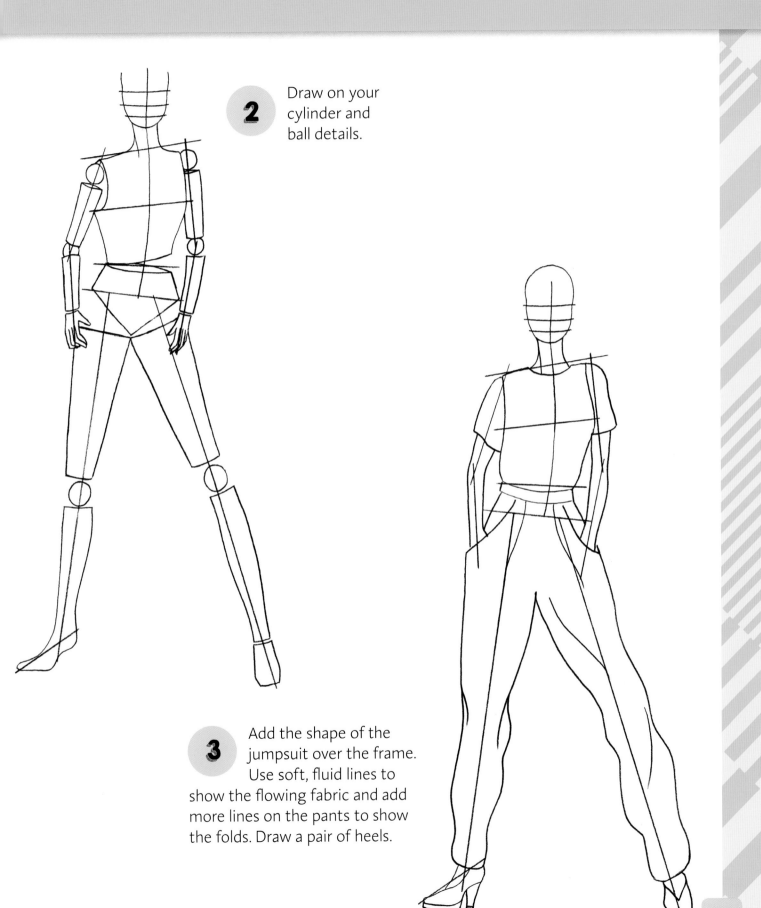

2 Draw on your cylinder and ball details.

3 Add the shape of the jumpsuit over the frame. Use soft, fluid lines to show the flowing fabric and add more lines on the pants to show the folds. Draw a pair of heels.

4 Remove the frame lines and draw in the facial features. Use a scribble stroke to create a head of long, wild curls. Then add side-swept bangs.

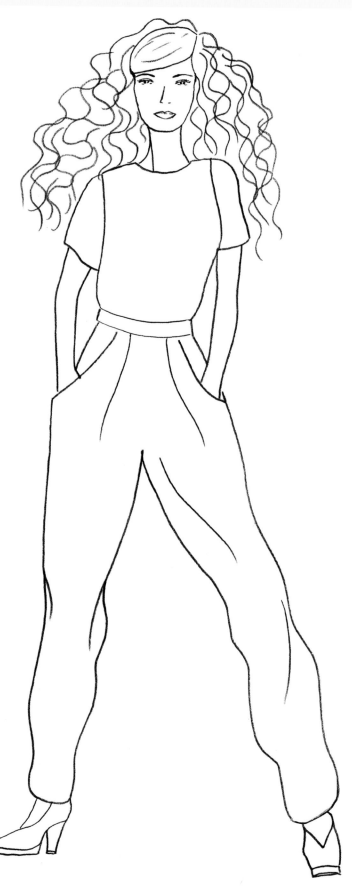

5 Draw in the jumpsuit print design of evenly spaced large and small leaves.

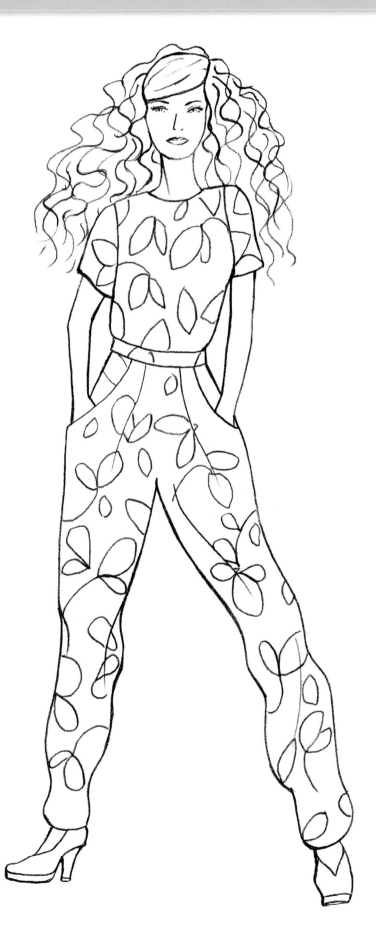

Design Icons

6 Work up your ink over your pencil. Use thick lines on the model's hair and body outline, and finer lines for the fabric folds and leaf print of the jumpsuit.

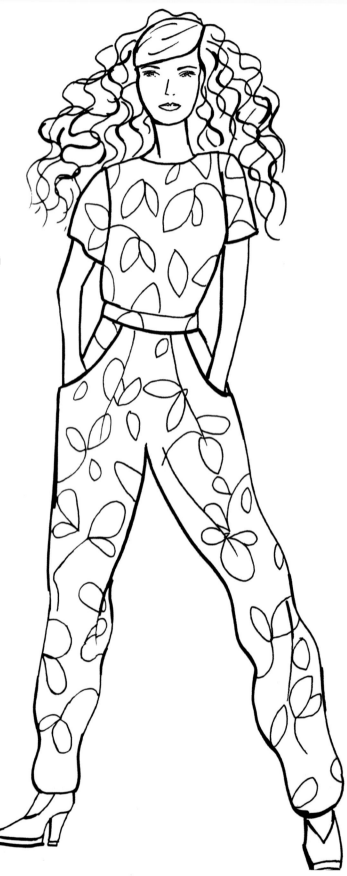

7 Use a midnight blue for the background with bright, primary colors for the leaf design. Add zingy black patterns on the leaves and tie the outfit together with shiny black heels.

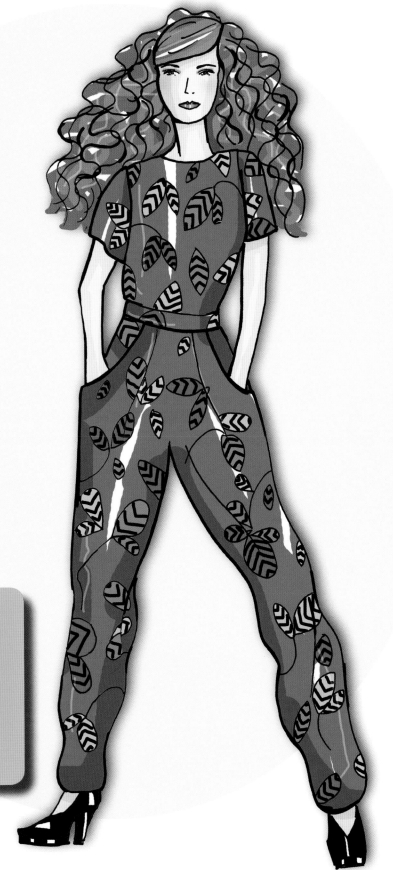

Stylist's Tip

Color the print carefully, paying attention to where the shapes will disappear into the folds of the fabric.

Design Icons

STYLE CARDS

Adding designer style to your wardrobe has never been easier. Any outfit can be given a whole new look and make you feel truly special with the addition of small designer accessories, jewelry, sunglasses, or perfume.

This Marc Jacobs headscarf is an easy way to add the designer look to any outfit.

Accessories

Designer jewelry can be used to make your outfit look sophisticated and stylish.

Be bold with this Tom Ford bracelet.

Marc Jacobs' heart earrings are perfect for daytime or evening.

For timeless style that works with anything, try this Marc Jacobs watch.

Add glamour to your updo with this beautiful Valentino hairclip.

Top off a special evening gown with a sparkling Valentino necklace.

Eyewear

Add style to your summer wardrobe with these delicate Tom Ford sunglasses.

Jewel-encrusted Valentino shades are the ultimate in eyewear style.

Perfume

Feel special with a range of designer scents.

Bags

Embellished bags can enhance any outfit.

This Tom Ford handbag and purse features an oversized twist closure.

Add style to your handbag with a Valentino studded coin purse.

Get the Valentino look with a sophisticated handbag

Keep it simple with a classic Tom Ford clutch.

Shoes

Complete your outfit with a pair of couture heels, or some designer strappy sandals.

Marc Jacobs' stylish shoes give a twist with contrasting blue straps.

Step out in summer style with these gold embellished Tom Ford flats.

Give your nails the designer treatment with Tom Ford polish.

Give black nails a boost with Marc Jacobs style daisy decals.

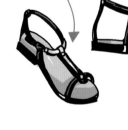

These elegant Marc Jacobs heels work perfectly with a little black dress.

Make a statement in these strappy Tom Ford sandals.

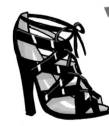

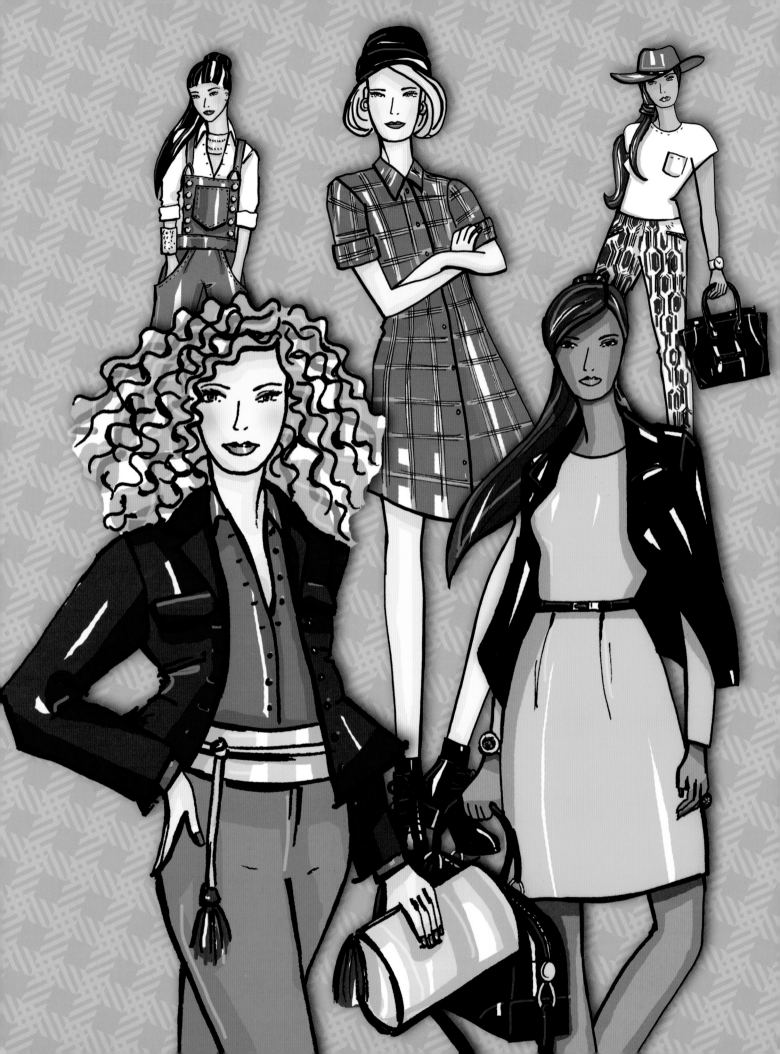